Matchsafes

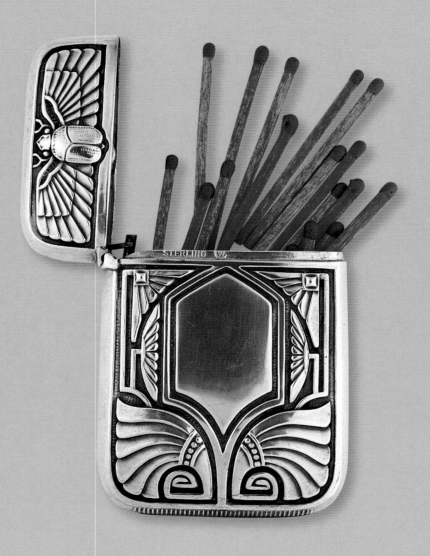

Matchsafes

DEBORAH SAMPSON SHINN

Scala Publishers
In association with
Cooper-Hewitt, National Design Museum
Smithsonian Institution

SCALA

Smithsonian
Cooper-Hewitt, National Design Museum

First published in 2001 by
Scala Publishers Ltd
Fourth Floor
Gloucester Mansions
140a Shaftesbury Avenue
London
WC2H 8HD

In association with
Cooper-Hewitt, National Design Museum
Smithsonian Institution
2 East 91st Street
New York, NY 10128–0669

ISBN 1 85759 237 9

Library of Congress Cataloging-in-Publication Data

Shinn, Deborah.
 Matchsafes / Deborah Sampson Shinn.
 p. cm.
 ISBN 1-85759-237-9
 1. Matchboxes—New York (State)—New York—Catalogs. 2. Cooper-Hewitt, National Design Museum—Catalogs. 3. Matchboxes—Collectors and collecting—Catalogs. 4. Matchboxes—History.
 I. Cooper-Hewitt, National Design Museum. II. Title.
 NK8459.M36 S53 2000
 688'.4—dc21
 00-011688

This publication has been made possible in part by the Andrew W. Mellon Foundation Endowment.

Notes Regarding the Illustrations
All matchsafes illustrated in this volume, with the exception of figure 15, are part of the collection of Cooper-Hewitt, National Design Museum, Gift of Carol B. Brener and Stephen W. Brener.

The dimensions given are the overall measurements, and they are given as height by width by depth.

Edited by Elizabeth Johnson
Designed by Anikst Design, London
Produced by Scala Publishers Limited
Printed and bound in Italy
Photographs edited by Jill Bloomer
Photographs, except where noted, by Matt Flynn

Frontmatter Photo Credits
page 1: Matchsafe with glass sides, 1915–16, possibly Edwin Henry Watts, marked "Asprey London," gold, glass, 3.5 × 4.5 × 1.4 cm, 1980–14–202

page 2: Matchsafe with Egyptian motifs, c. 1900, Watrous Manufacturing Company, Wallingford, Massachusetts, silver, 6.9 × 4.7 × 1.3 cm, 1980–14–1353

page 6: Detail of matchsafe with woman smoking, c. 1900, United States, silver, 5.7 × 4.3 × 1 cm, 1978–146–1248 (fig. 8)

Contents

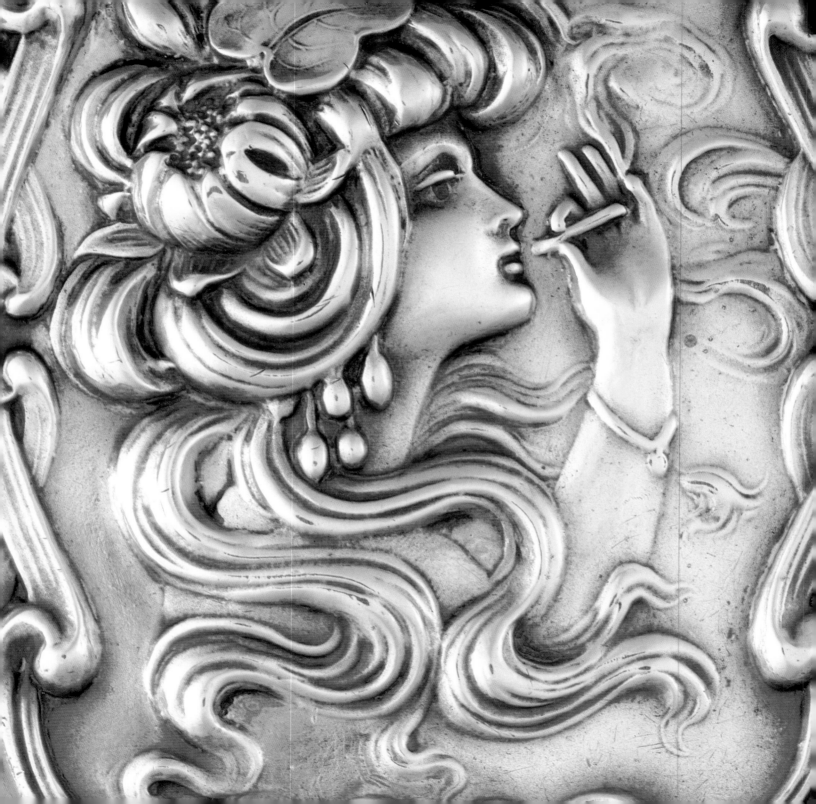

Preface

Cooper-Hewitt, National Design Museum is home to one of the most remarkable collections of design in the world. With more than 250,000 objects in four curatorial areas—Applied Arts and Industrial Design, Drawings and Prints, Textiles, and Wallcoverings—plus a library with more than 50,000 volumes, the Museum documents how people have given form, meaning, and purpose to the material world for over a millennium. Everyday and extraordinary objects alike tell stories of the multifaceted process of invention that the Museum recognizes as design.

Matchsafes are full of personality, and they are often quite beautiful. In the ensuing pages, Assistant Curator Deborah Sampson Shinn introduces us to this fascinating aspect of the collections of the Applied Arts and Industrial Design department. Deborah maps the genealogy of a once-commonplace accessory, now a highly prized artifact of the late nineteenth and early twentieth centuries. You'll find matchsafes that line up thematically—slews in the shape of miniature shoes, for example—as well as those that cohere stylistically, such as the elegant art nouveau cases.

They all served a common purpose: to protect friction matches that were highly combustible. What's fascinating is how that need, which disappeared with safety matches and the pocket lighter, inspired a seemingly endless number of permutations. Ornamental, often witty, each one is a conversation piece—a design conversation in which form and function exchange repartee, capturing not only the eye but also the imagination.

Special thanks are due to Deborah Sampson Shinn, Jeff McCartney, director of licensing, and Elizabeth Johnson, editor, at Cooper-Hewitt, and Dan Giles at Scala Publishers. Their efforts allow a wider audience to appreciate these delightful objects.

Susan Yelavich, *Assistant Director for Public Programs*

Opposite

Detail of figure 8

Introduction

Matchsafes are small containers for matches that became a vehicle for all manner of inventive design. They came into being when wooden friction matches were invented in the middle of the nineteenth century, and they were widely used until the 1930s, when safety matches, matchbooks, and gas-powered lighters became more popular. Early friction matches were somewhat unreliable and highly combustible. In order to protect them from moisture and carry them safely, without having them light spontaneously in a pocket, a closed container was needed to reduce extra friction. Matchsafes were the protective and decorative boxes into which matches bought in bulk could be transferred for one's personal use (fig 1).

In the United States, matchsafes were also called match boxes, match cases, or match receivers. In Britain, where friction matches have traditionally been known as vestas, matchsafes have generally been called vesta cases or vesta boxes. Some matchsafes were designed to hang on a wall, as in a kitchen or parlor near a stove or a lighting fixture. Others were made to stand alone on tabletops or desks, for use in smoking or in melting sealing wax for a letter. This book focuses on the vast number of decorative matchsafes produced specifically to be carried in a pocket, when a match might be needed on the go, especially for lighting a cigar, cigarette, or pipe.

The largest majority of pocket matchsafes were made from the 1870s through the 1910s, primarily in the United States, England, and other European countries, but also in Japan, China, and India, mostly for export. Although restricted somewhat by the size of matches and the requirements for a secure lid and a striking surface, an astounding variety of matchsafe designs was produced. U.S. patent records alone list more than one thousand designs for matchsafes registered between 1856 and 1930. Thousands of other designs are documented in contemporary advertisements, company archives, and matchsafe collections today,

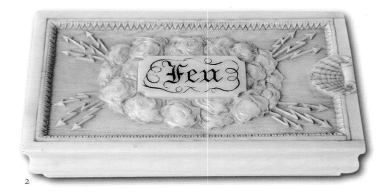

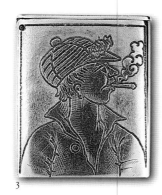

representing a remarkable range of different shapes, materials, workings, and decoration.

Matchsafes were made and marketed by jewelers, silversmiths, novelty companies, match manufacturers, and individual craftsmen. Manufacturers exploited exciting new materials of the period such as aluminum, celluloid, and early plastics, as well as more traditional substances including silver, brass, wood, ivory, shell, and stone. Although the majority of matchsafes were rectangular in form, neatly housing a couple of rows of matches, they were also made in the shape of shoes, shells, dragons, boats, beer bottles, boxing gloves, and just about any other mundane object of daily life or fanciful figment of the imagination. Some matchsafes were designed with extra gadgets for cutting cigars or additional compartments for storing stamps, pins, or tickets. Elegant and expensive matchsafes followed the height of fashion in the fine arts and in high-style design. Others featured advertising logos for manufacturers of livestock feed, cast iron beds, or rubber tires, just as pocket matchbooks advertise products and businesses today. Matchsafes of all kinds were brought home from foreign destinations as souvenirs. Many carried personal monograms or were ornamented with inscriptions commemorating celebrated public events.

The appeal of matchsafes as small precious objects is irresistible, and their many amusing novelties are an enduring delight. Matchsafes' inventive approach to problem solving, the encyclopedia of materials and techniques used in their manufacture, and the seemingly infinite array of shapes and decorative motifs manifested in these diminutive containers come together to form a virtual microcosm of design. A study of matchsafes is a study of design itself.

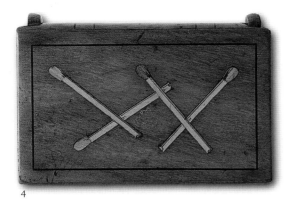

4

2

Matchsafe inscribed "Feu," late 19th century, France, ivory, pigment, 4.4 × 8 × 1.7 cm, 1978–146–314

3

Matchsafe with young man smoking, c. 1900, possibly Europe, metal, 3.8 × 3 × 1.3 cm, 1978–146–231

4

Matchsafe with inlaid decoration of matches inscribed "Jerusalem" (in Hebrew) on reverse, late 19th–early 20th century, Southern Europe or Middle East, inlaid wood, enamel, sandpaper, 6.2 × 4.4 × 1.3 cm, 1978–146–455

The age of matchsafes witnessed breathtaking advances in transportation, communication, materials science, and other technologies. Though matchsafes were clearly on a different scale than the gigantic oceanliners, soaring skyscrapers, and global reaches of radio waves and telephone lines that came into being during this period, they nonetheless paralleled some of the most exciting innovations and inventive products of an extraordinary, dynamic era. The social changes that transpired from the last half of the nineteenth century through the first quarter of the twentieth century forever changed the fabric of daily life. In form and decoration, matchsafes mirrored many of these changes, including the expanding role of women in society, the birth of trade unions, and the rise of mass tourism.

All of the matchsafes illustrated in this book are (unless otherwise noted) from the collections of Cooper-Hewitt, National Design Museum, Smithsonian Institution. They are part of a gift to the Museum, beginning in 1978, of more than four thousand pocket matchsafes from Carol B. Brener and Stephen W. Brener. One of the largest and most comprehensive of its kind, this outstanding collection offers a wonderful opportunity to explore the development and variety of matchsafe design and to examine matchsafes' unique role in the material culture of their period.

This book developed with invaluable assistance from other staff members and researchers at Cooper-Hewitt, National Design Museum, including Cynthia Trope, Todd Olson, Sarah Schleuning, Carol Grossman, Julia Haiblin, Claire Gunning, Stephen Van Dyk, Adrienne Scholz, and Josephine Loy. Emily Miller painstakingly catalogued the matchsafes. Elizabeth Johnson provided sure and graceful editorial guidance throughout the project. Dr. James Ulak of the Freer Gallery of Art/Arthur M. Sackler Gallery, Smithsonian Institution helped identify Japanese matchsafe subjects. Generous support from George Sparacio of the International Match Safe Association and Anna Marie Sandecki and Louisa Bann at the Tiffany & Company Archives is deeply appreciated. The text has benefited tremendously from a number of fine books published on the subject of matchsafes in recent years, as noted in Further Reading.

Chapter One

The Age of Matchsafes

Developed around 1830 by a number of chemists working independently, the earliest friction matches were a major life-enhancing innovation allowing—for the first time—instantaneous fire. Before this, fire was generated by a number of laborious and unreliable means, including rubbing together two pieces of wood or a flint and steel, to create a spark to ignite a wick or some dry mossy material. Some of the earliest experimental matches required dipping coated splints into vials of volatile sulfuric acid for ignition. Others, like the "Promethean" match invented by Samuel Jones, consisted of a glass bead full of acid wrapped in treated paper that was set on fire when broken against one's teeth.

These unwieldy and hazardous methods of ignition soon gave way to friction matches, which were basically splinters of wood or cardboard tipped with a chemical solution that would ignite when rubbed across a rough surface. "Congreve" matches, developed by English chemist John Walker, were tipped with a chlorate of potash and sulfide of antimony that ignited with a sputtering explosion of foul-smelling sparks. They were named after war rockets invented several years earlier by Sir William Congreve. Spark-throwing friction matches introduced around the same time by Samuel Jones were christened "Lucifers."

By the early 1830s, Charles Sauria of France and others in Germany and Austria developed a formula for match heads that incorporated white or yellow phosphorus, producing a more reliable and odor-free ignition. Red phosphorus was later substituted, after white phosphorus was discovered to be the cause of "phossy jaw" disease (necrosis) in match manufactory workers. In 1836 Alonzo D. Phillips of Springfield, Massachusetts, was awarded the first American patent for friction matches. By this time, many match factories had begun to appear in the United States and in England, as well as in Germany, Austria, and other European countries.

Opposite

Detail of figure 6, bottom left

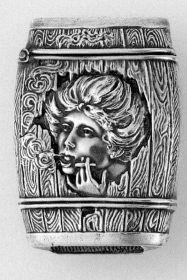

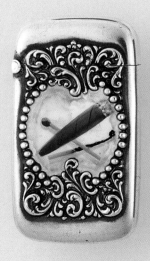

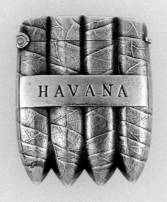

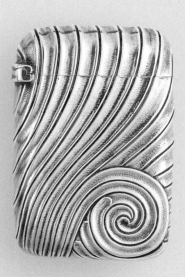

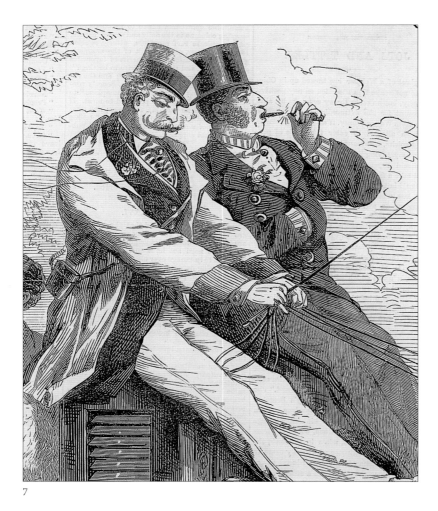

7

5 *Page 14*

Top left. Matchsafe in the form of a barrel with image of a woman smoking, c. 1895, United States, silver, 6 × 4.1 × 1.3 cm, 1982–23–36

Top center. Matchsafe in the form of a tobacco pouch, c. 1890, United States, silver, 5.2 × 3.8 × 1.3 cm, 1982–23–39

Top right. Matchsafe with gentleman dressed in 17th century costume smoking a clay pipe, c. 1900, Reed & Barton, Taunton, Massachusetts, silver, enamel, 6.7 × 3.1 × 1.3 cm, 1978–146–406

Bottom left. Matchsafe with cigar and matches, c. 1900, Reeves & Sillcocks, New York, silver, enamel, 5.7 × 3.1 × 1 cm, 1978–146–378

Bottom center. Matchsafe with peasant man smoking a pipe, c. 1900, Italy, inlaid wood, enamel, sandpaper, 6.6 × 3.6 × 1.5 cm, 1978–146–410

Bottom right. Matchsafe with stylized swirling lines, c. 1900, Europe, silver, 4.5 × 3.3 × 1 cm, 1978–146–1074

American matches were known as "loco focos" after the Latin term *loco foci* (in place of fire). In England, "wax vestas," with stems made of wax-coated cotton wicks, like tiny candles, became the most popular form of friction match.

Further developments in the design and production of matches during the nineteenth century included the safety match, patented by J. E. Lundstrom of Sweden, in 1855, which separated combustible components between the match head and a specially treated striking surface. These were not used widely until later in the century. In 1892, American patent

attorney Joshua Pusey invented covered matchbooks, while a similar innovation labeled "Pyroca" was developed in Germany. A related form, called "Fusees," had been produced since the 1850s, as bundles of wooden matches attached at their bases, from which several at a time could be broken off as needed. The Diamond Match Company purchased Pusey's patent for covered matchbooks in 1895, and moved the striking surface to the outside of the matchbook to further improve safety. According to Diamond Match Company records, by 1908 one billion matches were being made and ignited per day in the United States.

"Vestas," "Lucifers," and the other evocative names chosen for the first friction matches clearly reflect early Victorian tastes for traditional mythological and biblical themes. The names also reveal the dramatic nature of match ignitions and provide illuminating clues for initial uses of friction matches. Vesta was the ancient Roman goddess of the hearth and was regarded as the protector of domestic union and happiness. Six vestal virgins guarded the eternal flame at her sanctuary in Rome. The invocation of Vesta's name for use in lighting kitchen stoves, parlor fires, and chamber candlesticks would have been quite appropriate. According to interpreters of the Bible, Lucifer was the fallen angel or Satan himself. The blue flames, sulfuric odors, and fiery sparks that flew when early friction matches were lit must have looked and smelled like the very flames of hell. One can well imagine these matches enlisted in the service of such devilish vices as smoking pipes, cigars, and cigarettes.

The smoking of pipes, cigars, and cigarettes was, in fact, an increasingly integral part of the social scene during the second half of the nineteenth century, both among common people and in high society. Georges Bizet's 1875 opera *Carmen* starred a sultry Spanish vixen who worked in a cigarette factory, and it featured choruses of smokers in street scenes and tavern tableaux. By the 1880s, upper-class gentlemen smoked their cigars in the elaborately furnished smoking parlors of hotels, railroad cars, city clubs, or private homes (fig. 7).

Tobacco had been introduced to Europe from the New World by Columbus, on his return from the 1492 voyage to the West Indies. From that time until the nineteenth century, tobacco was taken mostly by smoking a pipe or inhaling powdered snuff. Cigars and cigarettes, introduced from Spain, rose to popularity during the middle decades of the nineteenth century. The first cigarette manufactory in the United States was established in the 1860s, and by the 1880s cigarettes were being mass-produced in factories equipped with rolling machines that could produce

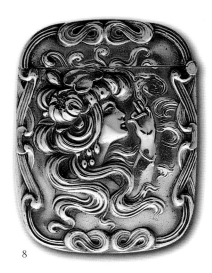

8

more than a hundred thousand cigarettes per day. The invention of reliable friction matches at the same time was a major boost to the popularization of cigar and cigarette smoking, as was the development of matchsafes, which allowed the lights to be stowed safely and conveniently at hand.

Smoking themes are a common decorative device of matchsafes. Some of the most popular were scenes of men relaxing at tavern tables with pipes in hand, or dreamy-eyed women puffing on cigarettes while wavy plumes of smoke encircle their faces (fig. 8). Other novelty matchsafes were made in the shape of wooden cigar boxes, ash-tipped cigar butts, or leather tobacco pouches (figs. 9, 10). A scene depicted frequently on matchsafes is the temptation of Saint Anthony, in which Anthony is usually portrayed in earnest prayer, while either a devil or a beautiful woman vies for his attention (fig. 11). Perhaps the popularity of this theme reflected the emerging struggle to resist such bad habits as smoking.

While wall or table matchsafes made for use at home fell into the domain of women, pocket matchsafes were more often used by men. Usually stashed in a man's vest pocket or sometimes attached to a watch chain, pocket matchsafes were readily available for lighting a pipe, cigar, or cigarette while at home or traveling. Contemporary advertisements in gift catalogues listed pocket matchsafes as the "perfect gift" for gentlemen. The decoration of matchsafes far more often reflects masculine interests and preoccupations, as can be seen in the many boxes that feature sporting motifs, fraternal order insignias, and business-related themes.

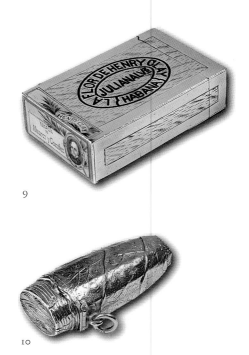

9

10

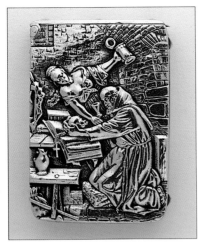

11

8

Matchsafe with woman smoking,
c. 1900, United States, silver,
5.7 × 4.3 × 1 cm, 1978–146–1248

9

Matchsafe in the form of a cigar
box, inscribed "La Flor de Henry
Clay, Julianalvz., Habana" and
"Henry Clay, Regalia de Alvarez
y González," late 19th century,
unidentified marks, Europe, silver,
enamel, 3 × 4.6 × 1.2 cm,
1982–23–11

10

Matchsafe in the form of a cigar
butt, late 19th century, unidentified
mark, France, gold, metal,
4 × 1.7 × 1.2 cm, 1982–23–89

11

Matchsafe with scene of the
Temptation of St. Anthony, late 19th
century, possibly Europe, silver,
5 × 3.3 × 1 cm, 1978–146–1112

Throughout the nineteenth century, it was considered highly improper for a lady of station to smoke in public. After the turn of the century, however, as women began to gain ground in lobbying for equal rights, they were seen lighting up in polite company. An article in the December 15, 1916, edition of *Vogue* featured elegant smoking accessories and reflected that "it wasn't so very long ago—when if a woman smoked in an American hotel, people gazed at her in wide-eyed wonder and murmured apologetically, 'She must be an actress.' . . . Now there is no more thrill in seeing a woman smoke in public than there is in seeing her use her finger-bowl." Describing the art of smoking as women's "indoor sport," the article also ranked matchsafes, along with cigarette cases and cigarette holders, as among the many "necessary absurdities" required by smokers.

By 1920, the year that the Nineteenth Amendment to the U.S. Constitution guaranteed women the right to vote, women were smoking in public and had become important users of pocket matchsafes and other smoking accessories. Advertisements in the ultra-fashionable Parisian magazine *Gazette du Bon Ton* showed women smoking while modeling couture evening dresses. Matchsafes designed specifically for women included delicate jeweled models, sometimes with chain attachments for fastening to a bodice pin or a belt chatelaine. A few are found engraved with inscriptions of female names, and some are ornamented with images of adventurous young women playing golf or tennis.

Chapter Two

Makers and Manufacturers

The amazing variety of matchsafe designs produced from the 1870s to the 1920s was due in large part to the wide range of makers and manufacturers engaged in their production. Jewelry houses, silversmiths, novelty companies, and match manufacturers issued thousands of designs (pages 22–23). Many were made in small craft workshops or by individual hobbyists. Most were marketed through department stores and smaller specialty shops, mail-order catalogues, or trade journals.

Nearly all the prominent jewelers active in the years around the turn of the century counted jeweled pocket matchsafes among their precious offerings. The house of Cartier, based in Paris, produced elegant multi-colored gold matchsafes and matching cigarette cases in the art deco style. A thin gold case with a cabochon sapphire knob is typical of Cartier matchsafes from the 1920s (fig. 13). When the sapphire knob is slid up a groove on the case's front side, the top opens and flips back, allowing matches to rise out from an interior compartment. Other Cartier matchsafes were ornamented with enamel designs based on French eighteenth-century snuff boxes, and they were often paired with cigarette cases.

Tiffany & Company of New York, founded by Charles Louis Tiffany in 1837, supplied gold and silver matchsafes along with their award-winning jewelry, tablewares, and other luxury items. A matchsafe in the Japanese style, echoing the Tiffany designs for silver tablewares, has a diagonal opening, hand-hammered surfaces, and applied ornament in copper and brass of a maple leaf and seed pod. A stylized monogram is featured on the other side, and a tiny beetle clings to the top of the lid (fig. 14). Among matchsafes exhibited by Tiffany & Company at the Paris World's Fair of 1889 was an unusual case in the form of a raven's head (fig. 16). According to an April 1889 article in *The Jewelers' Circular and Horological Review*, its design was based on decorative motifs from the Chilkat

Opposite

Detail of figure 13

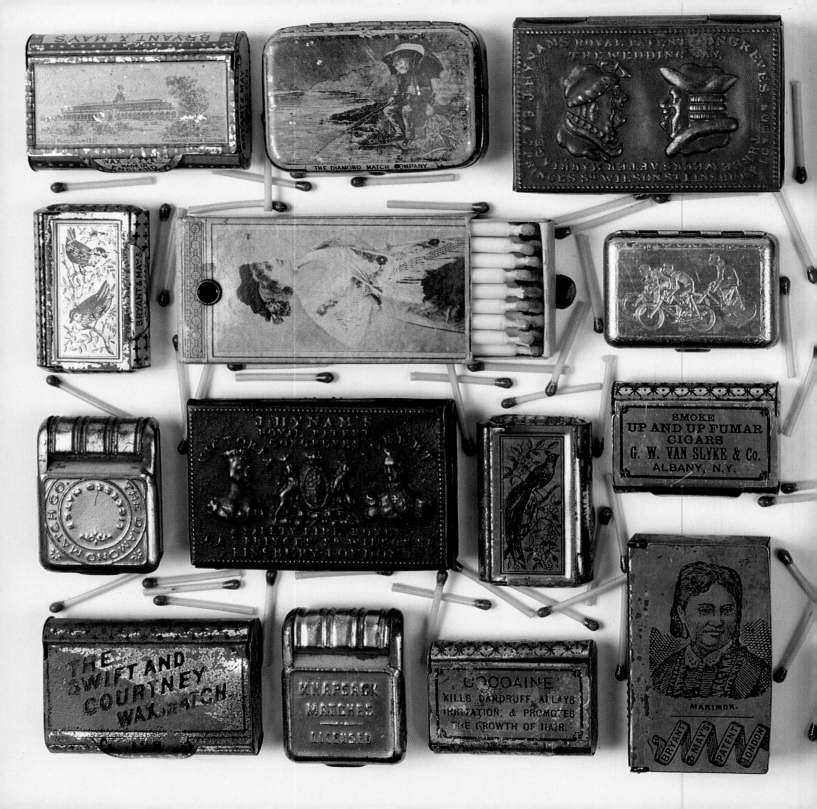

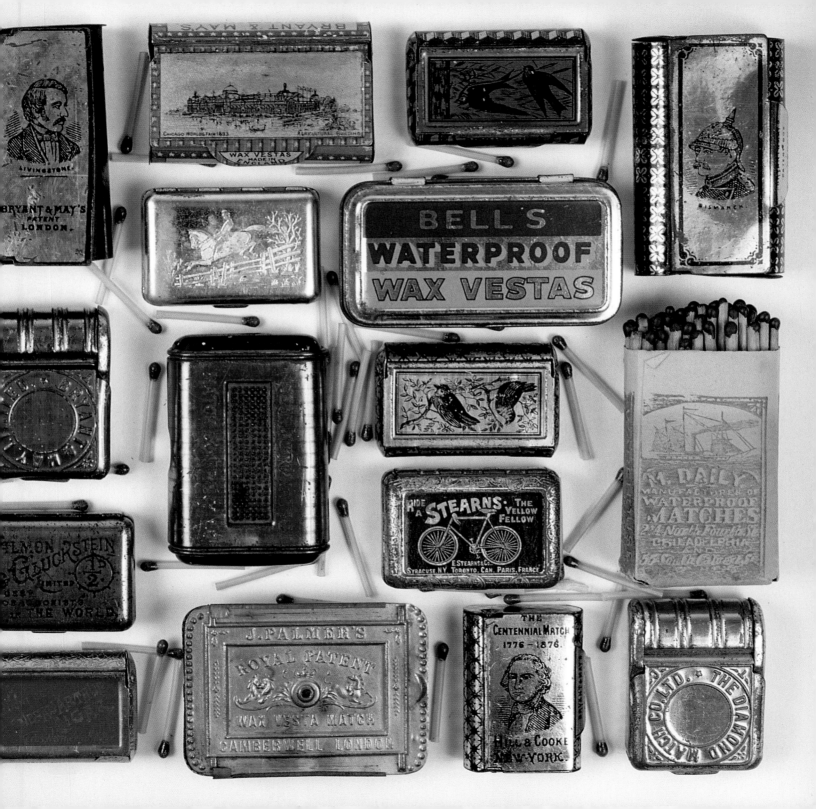

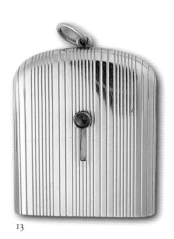

13

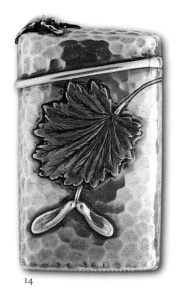

14

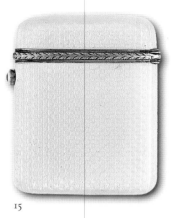

15

Indians of the American Northwest Coast, and it was made of iron inlaid with gold, abalone pearls from California, and turquoise from New Mexico.

The St. Petersburg firm of Fabergé, patronized extensively by the Russian imperial court, created matchsafes with exquisite enamel decoration and expert jade carving. A diminutive case covered with translucent blue enamel over an engine-turned ground is banded around the lid by a classical leaf border and has a jeweled pink sapphire knob (fig. 15). A series of gold match cases made in the Fabergé workshops was engraved with Empire style motifs such as eagles, wreaths, ribbons, and palmettes. Many Fabergé matchsafes were designed en suite with elaborately jeweled gold, enameled, and hardstone cigarette cases.

The United States was one of the world's leading silver producers from the 1860s to the end of the century. The silver mines of Nevada's Comstock Lode and others in the western states were supplying massive quantities of raw metal. Back east, silver tablewares, jewelry, and other decorative items were avidly purchased by a steady market of well-to-do patrons and an increasingly prosperous middle class.

Hundreds of silver companies were established during these years, especially in New England and the New York area, including many that produced a diverse range of silver and silver-plated matchsafes. Some of the most prominent firms that featured matchsafes among their wares were the Gorham Manufacturing Company and Theodore W. Foster &

12 *Pages 22–23*

Matchsafes produced for Bryant & May, J. Hynam, Roche & Cie, The Diamond Match Company, and others, 1850–1910, England, France, United States, tin-plated metal, paper, and other materials

13

Matchsafe with retractable inner compartment, c. 1920, Cartier, Paris, gold, sapphire, 4.5 × 3.6 × 1.9 cm, 1978–146–469

14

Matchsafe in the Japanese style, c. 1885, Tiffany & Company, New York, silver, copper, brass, 6.3 × 3.6 × 1.6 cm, 1980–14–1296

16

15

Matchsafe with enamel decoration,
c. 1900, Fabergé, St. Petersburg,
workmaster August Wilhelm
Holmström, silver, gold, enamel,
pink sapphire, 4.5 × 3.6 × 1 cm,
1978–146–482

16

Matchsafe in the form of a stylized
raven's head, c. 1889, Tiffany &
Company, New York, iron, gold,
pearls, turquoise, rhodonite,
10.3 × 2.8 × 2 cm (Collection of
Margery and Edgar Masinter)

Brother, both in Providence, Rhode Island. Firms in southeastern
Massachusetts included Reed & Barton, the Frank M. Whiting Company,
the Pairpoint Manufacturing Company, R. Blackinton & Company, and
F. S. Gilbert. Factories in Connecticut included the Meriden Britannia
Company, R. Wallace & Sons Manufacturing Company, and Maltby
Stevens & Curtiss.

The firms that worked in New York City included the Whiting
Manufacturing Company, George W. Shiebler & Company, Wood & Hughes,
and Howard & Company. Around the turn of the century, Newark, New
Jersey, was home to many jewelers and silver manufactories where match-
safes were made. Among the most prominent there were Unger Brothers,
Battin & Company, and the William B. Kerr Company. Matchsafes made
by these silver firms are usually—but not always—stamped with maker's
marks that are identifiable through various published references.

In originality of design and high quality of production, the Gorham
Company was one of the leading producers of matchsafes in America.
Scores of different designs were produced, with decoration that ranged
from hand-hammered surfaces in the arts and crafts style, richly
embossed relief ornament in rococo and art nouveau patterns, naturalis-
tic motifs in the aesthetic style, mixed metal motifs following Japanese
designs, colorful enameled patterns, as well as faux leather surfaces and
other trompe l'oeil effects. Among the Gorham matchsafes based on

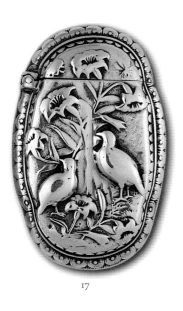

17

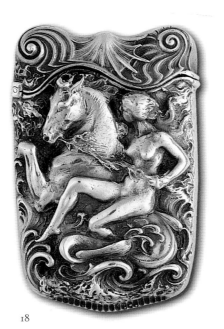

18

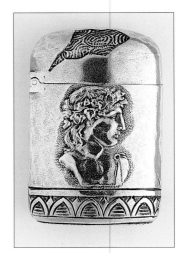

19

exotic Eastern motifs is a silver case probably dating from the 1880s with relief decoration of quail under a flowering plant on one side and a rooster and hen amid flowers and foliage on the reverse (fig. 17). Other Gorham matchsafes are ornamented with elegantly subtle relief designs of more abstract, geometric patterns (see page 15 bottom right).

Matchsafes made by the silver companies often closely reflect the same skillful techniques and fashionable patterns used for their larger hollowware and flatware pieces. The unusually high relief decoration on a matchsafe made by the Whiting Company exemplifies this firm's expert relief work, engraving, and applied work (fig. 18). The lid is adorned with watery swirls and has an undulating seam where it meets the case. On one side of the body a sprig of seaweed is splayed across a plain background above an elaborate engraved monogram. A water nymph riding a sea horse amid roiling waves covers the other side. The horse and water nymph are sharply undercut to give a pronounced three-dimensional quality.

A silver matchsafe by George Shiebler uses a highly original version of the Medallion pattern, which was popular in silver flatware and other tablewares and was offered by a host of manufacturers starting in the 1860s (fig. 19). Medallion pieces feature classical figural busts and other

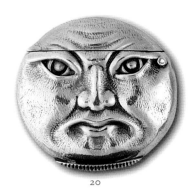

20

motifs based on ancient Greek and Roman coins. One side of Shiebler's matchsafe shows a bust of a Bacchic figure with grapevine diadem, a band of egg and dart molding, and a vaguely ruinlike motif on the lid. The reverse shows busts of Mars, the war god, with helmet and shield, and Diana, goddess of the hunt, amid various classical motifs. From the late 1870s to 1907 Shiebler's firm produced quirky designs for matchsafes, tablewares, jewelry, and silver novelties that were often modeled after Antique or Japanese compositions (fig. 20).

The age of matchsafes was also the "age of novelties." The amount and availability of small manufactured articles designed for household decoration or personal use grew tremendously between 1850 and the First World War. More middle-class homes, an increase in leisure time and expendable income, and the proliferation of factories capable of mass-producing inexpensive wares kindled the production of novelty items in the United States, Britain, and Europe. Smoking articles of all kinds were often included in catalogues advertising novelty company wares. A trick cigar, advertised in an 1886 edition of the Peck & Snyder catalogue of equipment for sports and pastimes, suggests the growing appeal of the novel. The ad copy describes it as "Amusing, Booming, Confounding, Defying, Exciting, Fascinating, Something Entirely New."

Sampson Mordan & Company of London was one of the largest British producers of matchsafes and other novelties. Although the company originally gained fame for its patented Ever-Pointed mechanical pencil in 1822, it went on to produce hundreds of other types of novelty articles including boxes, scent containers, toilet wares, office fittings, and locks. By 1889 Sampson Mordan was advertising, among other goods, "gold and silver cigar cases, cigarette cases, match boxes, cigar cutters, spirit lamps and other requisites for smokers." Silver matchsafes by Sampson Mordan were made in all sorts of shapes—barrels, sentry boxes, hogs, and other animals among them. A number were engraved with scenes based on Kate Greenaway's illustrations for children's books. Around 1900, Sampson Mordan began producing silver matchsafes with beautiful painted enamel decoration of subjects such as uniformed soldiers, alluring ladies, and scenes of coaching, hunting, fishing, and other sports (fig. 21).

Many of the Sampson Mordan matchsafes were made in small silver workshops in cities outside London, including Birmingham and Chester. Birmingham had its own distinctive style of silver work, with engraved all-over patterns, often with a cartouche- or shield-shaped area left plain for a monogram (see figs. 43, 46). The hundreds of workshops located here

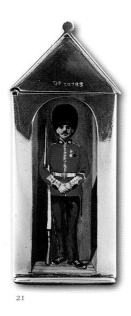

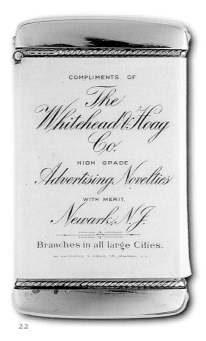

21

22

supplied matchsafes for larger British firms and were exported overseas extensively. The Birmingham matchsafes, and others made in Britain, are generally stamped with identifying hallmarks that indicate the quality of silver, the city of origin, the year of manufacture, and a maker's mark.

In the United States, one of the major novelty and matchsafe producers was the Whitehead & Hoag Company of Newark, New Jersey. Whitehead & Hoag gained success by manufacturing political button pins, jewelry, badges, and other novelties made of celluloid with printed decoration. Just after the turn of the century, Whitehead & Hoag began producing plated metal matchsafes wrapped with celluloid collars bearing printed advertisements. They became the major manufacturer of this kind of matchsafe, one of the most popular types of pocket matchsafes produced between 1900 and 1915. A matchsafe marked by Whitehead & Hoag is printed with the company's own advertising on one side and, on the other, a polychrome image of Cupid and Psyche, deities from ancient Roman legend (fig. 22). Whitehead & Hoag also provided celluloid covers with printed designs for other manufacturers of match cases.

Scores of other novelty companies advertised their wares in such trade

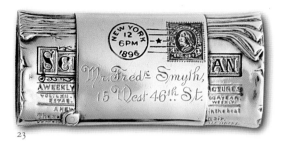

23

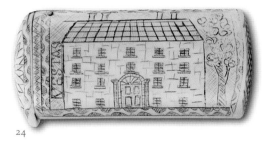

24

journals as *The Jewelers' Circular*, published in New York starting in 1869. In an 1892 ad, Enos Richardson & Company of New York illustrated a matchsafe in the form of a *Scientific American* magazine rolled and addressed for mailing (fig. 23). The ad copy for this patented design claimed that it was the "most successful silver novelty ever put on the market." Ornately scrolled silver matchsafes, advertised by Solomon Bros. & Gross of New York, "makers of the most extensive line of Sterling Silver Novelties on the market," were priced from $7.50 to $12.00 per dozen.

When Fusees, Lucifers, and Vestas were introduced, match manufacturers themselves were some of the first to provide ornamental containers along with their lights. London matchmaker John Hynam designed and manufactured some of the earliest pocket matchsafes in the 1840s and 1850s. An early Hynam matchsafe made of tin is decorated with busts of Queen Victoria and Prince Albert framing a royal insignia and is inscribed "J. Hynam's Royal Patent, Congreves, & Safety Fire Boxes, 5 & 7 Princes Sq., Wilson St., Finsbury London" (see pages 22–23).

Bryant and May, one of Britain's leading producers of wax vesta

matches, issued a wide range of printed tin-plated match containers from the 1860s through the 1930s (see pages 22–23). Although inexpensive and mass-produced, with an emphasis on functional design, the matchboxes were highly imaginative in their decoration. One series of pocket matchsafes was ornamented with the busts of famous historical figures and prominent people of the day. Other boxes were printed with elaborate royal coats of arms, scenes of popular pastimes, or advertising copy for Bryant and May or other companies. Large boxes made to hold one thousand matches were printed with bold Japanese-inspired compositions or with idealized arrangements of birds, flowers, and ribbons. A number of Bryant and May matchsafes were decorated with images of the ten prize medals won by the firm at the various World's Fairs.

Among other match manufacturers who produced pocket matchsafes were Bell & Company of London, one of the earliest makers of wax vestas, who advertised "New Patent Gas Camphorated Congreve Lights without Sulphur." Roche & Cie of Paris and Marseille, France, issued paperboard matchsafes for their candle matches, printed with images of glamorous women and equipped with a socket to support an upright match. The Diamond Match Company of the United States, founded in 1881, commissioned a number of manufacturers to produce tin matchsafes for their wooden matches (see pages 22–23).

From the earliest days of friction matches through their heyday, individual craftsmen and hobbyists around the world put themselves to the task of fabricating small, portable containers. Meant for personal use, as gifts, or for commercial exchange, these matchsafes generally followed local craft traditions. Small workshops supplied the growing tourist trade throughout Europe. In Germany, Austria, and Switzerland, for instance, carved wood and antler matchsafes ornamented with edelweiss blossoms or mountainous scenes were sold as souvenirs. Italian craftsmen also supplied lovely intarsia, or inlaid, wooden matchsafes to travelers.

Some matchsafes crafted from ivory and bone were made by sailors who worked on scrimshaw articles while on long sea voyages. A charming matchsafe of carved ivory bears the engraved decoration of a Georgian house with the inscription "Vestas" on one side, and on the other a vase of flowers (fig. 24). Soldiers and prisoners, two more groups who experienced extended periods of inactivity, also contributed inventive individualistic matchsafe designs. Matchsafes were sometimes fashioned from bits of spent shell casings during the First World War. A matchsafe made of paperwork in the shape of the entrance to a prison cell, with the number

25

Matchsafe in the form of a prison cell entrance, late 19th century, probably Europe, painted and varnished cardboard, thread, sandpaper, 6.6 × 3.8 × 1.7 cm, 1978-146-520

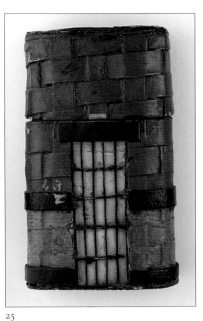

25

43 inscribed next to the door, may have been made by the occupant of a similar room (fig. 25).

Although the manufacturers of many matchsafes can be identified by maker's marks on the cases, the individuals responsible for their design are much less known. Designers can sometimes be traced through U.S. Design Patent records and similar documents in other countries. Rarely, company archives identify designers in their documents. The May 26, 1897, issue of *The Jewelers' Circular* published nine designs for matchsafes, the winners of a competition at the Rhode Island School of Design. Following the custom of the day, the student designers who were named so prominently in the article would have receded to a status of anonymity once they joined silver companies or jewelers after graduation.

Materials

A cornucopia of natural and man-made materials was called upon for the production of pocket matchsafes during the late nineteenth and early twentieth centuries. From traditional materials to newly invented substances, from precious to common, from costly to inexpensive, and from the exotic to the mundane—all were employed in the production of boxes designed to contain the magic of fire (pages 34–35).

Tin, brass, copper, and other base metals were used for some of the earliest pocket matchsafes dating from the 1840s and 1850s. An early matchsafe design with a sliding lid, patented by Alexander S. Stocker in England in 1848, was executed in stamped brass. Tin-plated metal was used for matchsafes issued by some of the match manufacturers starting around 1850. Tin plating helped protect the thin iron or steel sheeting underneath from corrosion and was often printed or stamped with decorative surfaces. Copper, also used in early matchsafe production, was popular again with matchsafes made around the turn of the century under the influence of the arts and crafts movement, which espoused the use of common metals. Base metals continued to be used for inexpensive cases made in the United States, Britain, Europe, and the Far East throughout the matchsafe era.

For the most expensive pocket matchsafes, gold or silver was the preferred material. Solid gold matchsafes were made mainly by jewelers and were relatively rare (fig. 28). Gold does show up often, however, as a thin wash lining for the inside of silver matchsafes. As a more noble—or stable—metal, gold could prevent sulfur match heads from degrading the silver surfaces.

Sterling silver and silver-plated metals were the most popular materials used in matchsafe production. Silver's durability, versatility, and appealing reflective and tactile qualities made it an ideal medium. Silver can be

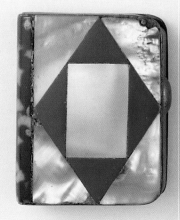
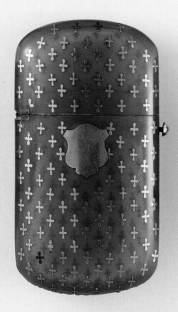
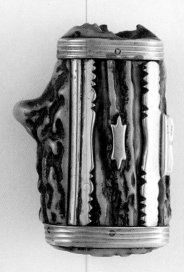

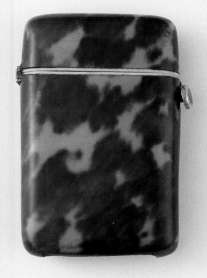
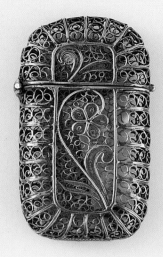
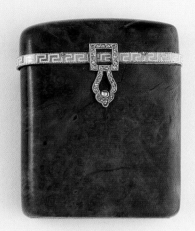
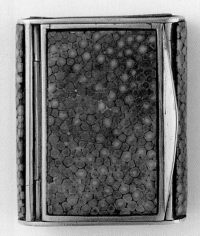
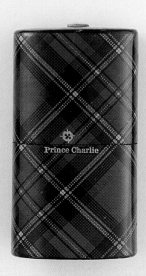
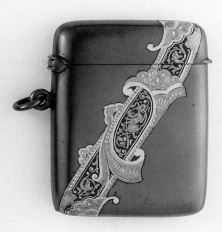

Prince Charlie

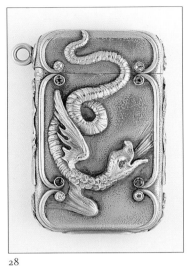

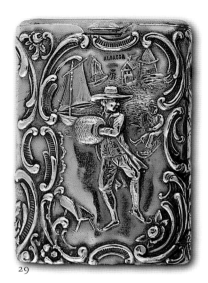

28

29

26 *Page 34*

Top left. Matchsafe with monogram, c. 1900, signed "Frank Hyams Company 128 Bond St. W," London, nephrite, gold, 5.7 × 5.6 × 1 cm, 1978–146–461

Top center. Matchsafe made of brown agate, c. 1900, Europe, agate, silver, 5 × 2.9 × 2.1 cm, 1982–23–1367

Top right. Matchsafe made of vulcanite inscribed "'Chloride,' Wood Separator," c. 1910, probably United States, vulcanite, 4.4 × 4 × 1.2 cm, 1980–14–182

Bottom left. Matchsafe in the form of a book, c. 1910, possibly Europe, mother-of-pearl, plastic, plated brass, 4.5 × 3.7 × 1 cm, 1980–14–259

Bottom center. Matchsafe with piqué work, late 19th century, possibly France, horn, gold, 6.6 × 3.7 × 1.6 cm, 1978–146–298

Bottom right. Matchsafe made of antler, late 19th century, probably Europe, antler, metal, 5.5 × 2.8 × 1.9 cm, 1978–146–310

27 *Page 35*

Top left. Matchsafe veneered with tortoiseshell, late 19th century, Europe, tortoiseshell, bone, gold, metal, 6 × 4.2 × 1.2 cm, 1978–146–304

Top center. Matchsafe made of silver filigree, late 19th century, probably Europe, silver, 5.6 × 3.4 × 1 cm, 1978–146–615

mixed with other metals, decorated with colorful enameled decoration, or set with precious or semiprecious gemstones. First used in any quantity in the 1870s, silver continued to be a popular material for matchsafe production through the 1920s. Some of the most elaborate silver work found on matchsafes is in the form of filigree decoration, composed of thin metal wires arranged in openwork patterns (see page 35 top center). A technique used in jewelry since ancient times, filigree was made in many European countries, as well as the Near East and Asia.

The process of electroplating, invented by the British metalworker George Richard Elkington at about the same time that friction matches appeared on the market, allowed other less expensive metals, usually copper or nickel, to be coated with a thin layer of silver through an electrolytic process. Electroplated silver was used extensively by matchsafe makers in England, the United States, and throughout Europe. Some British matchsafes bear the mark E.P.N.S., for electroplated nickel silver, or silver-plated nickel. Nickel silver, also known as German silver or Alpacca—an alloy of about fifty parts copper, twenty-five parts nickel, and twenty-five parts zinc—was used extensively for electroplating. An Alpacca mark usually indicates German or European origins. A matchsafe decorated on one side with a scene of an ice skater framed by a

Top right. Matchsafe made of burl-wood, c. 1910, unidentified maker's mark, France, burlwood, gold, enamel, diamonds, 5 × 4 × 1.4 cm, 1978–146–316

Bottom left. Matchsafe veneered with shagreen, c. 1910, probably France, plated metal, shagreen, 4.9 × 4 × 1.2 cm, 1978–146–306

Bottom center. Matchsafe with "Prince Charlie" tartan pattern, late 19th century, possibly William & Andrew Smith, Scotland, wood, printed paper, ivory, 5.6 × 3 × 1.2 cm, 1978–146–308

Bottom right. Matchsafe made of gun metal, c. 1900, possibly Europe, gun metal, gold, 4.8 × 4 × 0.9 cm, 1978–146–1104

28

Matchsafe with dragon, 1905–15, Theodore B. Starr, New York, gold, diamonds, emeralds, rubies, 5.1 × 3.7 × 1 cm, 1978–146–464

29

Matchsafe with ice skater, late 19th century, marked "Alpacca," and other unidentified mark, probably Germany, silver-plated metal, 6 × 4.3 × 1.1 cm, 1978–146–1156

30

Matchsafe made of aluminum, c. 1898, United States, aluminum, glass beads, 6.6 × 3 × 1.2 cm, 1980–14–842

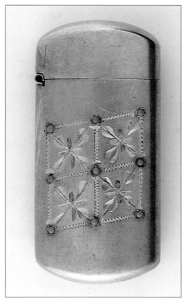

30

scrolled cartouche carries a prominent Alpacca stamp amid the scroll ornament near the top edge (fig. 29).

White metals and other alloys, designed to imitate the look of costlier silver, were also used for matchsafe production. The Bristol Silver Company of Attleboro, Massachusetts, used an alloy they named "Silveroin," with a slightly whiter and duller surface than silver. Other manufacturers used similar alloys for more affordable wares. It is not uncommon to find the same matchsafe model executed alternatively in sterling silver, in one of the other imitation silver alloys, or in brass or a different metal altogether. Another inexpensive way to create a silvery surface for metal match containers was through nickel plating. Nickel was usually plated over brass, as can be seen on well-worn examples that have lost areas of their surface plating.

Another important nineteenth-century invention—the commercial processing of aluminum—was also exploited by matchsafe manufacturers (fig. 30). Although it had been discovered slightly earlier, aluminum was not available in any quantity until around 1890, when technological advances first allowed mass-production. Aluminum pocket matchsafes were being manufactured by the turn of the century, as evidenced in an advertisement placed by the E. A. Fargo Company in the September 2,

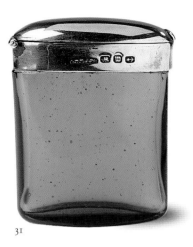

31

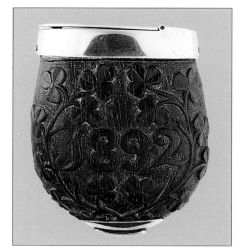

32

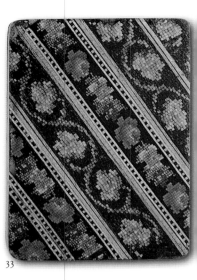

33

1903, issue of *The Jewelers' Circular-Weekly*. According to the ad, the aluminum "positively will not finger-mark, tarnish or corrode," and the decorative matchsafe illustrated could be retailed for a mere 25 cents. Other American manufacturers of aluminum matchsafes included the New Jersey Aluminum Company of Newark and the Western Aluminum Company of Chicago.

Fragile ceramics and glass were used widely for match containers designed to sit on tabletops, but less frequently for portable cases (fig. 31). Many pocket matchsafes carry colorful decoration in the form of enamel, a vitreous substance fixed by firing onto the metal surface (usually silver or brass). Painted enamels on matchsafes made by the British firm Sampson Mordan were some of the finest ever produced. Cloisonné enamel work, where enamel is placed between metal outlining bands, was used extensively on matchsafes made in Russia and China.

Among organic materials used in matchsafe production, wood and other vegetable matter are most common. Irish craftsmen carved blackened bog oak, from logs that had been buried for years in swampy areas, to make matchsafes ornamented with shamrocks, harps, and other traditional motifs (fig. 32). Other types of British wooden matchsafes included those made of Scottish tartan ware (see page 35 bottom center), painted or printed with tartan plaids, and Mauchline ware, featuring transfer-

31

Matchsafe made of green glass, 1896–97, unidentified maker's mark, Birmingham, England, glass, silver, 5.1 × 4 × 1.5 cm, 1980-14-1183

32

Matchsafe made of bog wood, c. 1892, Ireland, bog wood, plated metal, 5.3 × 4.3 × 2 cm, 1978-146-212

33

Matchsafe with wood mosaic decoration, 1900–20, Tonbridge, England, stained wood, sandpaper, 6 × 4.5 × 1.3 cm, 1978-146-299

34

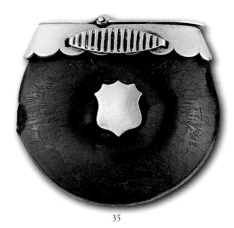

35

34

Matchsafe veneered with straw
work, c. 1900, probably France,
straw over cardboard, sandpaper,
7.5 × 4.2 × 1.6 cm, 1978–146–300

35

Matchsafe made from hollow seed,
late 19th century, probably
England, tropical bean (*Entada
scandens*), metal, 4.2 × 4.9 × 1.8 cm,
1978–146–549

printed scenes of local interest (see page 82 top center). Matchsafes made
of English Tonbridge ware, and similar ones made in Italy, were veneered
with mosaiclike patterns composed of different colored woods (fig. 33).
Italian matchsafes also featured figural intarsia, or inlaid, wooden decora-
tions (see figs. 4, 80).

In France, highly figured burl woods were crafted into elegant jeweled
pocket matchsafes (see page 35 top right). A sophisticated kind of straw
work was used as veneers, where slivers of various colored woods were
glued into intricate patterns (fig. 34). Many British matchsafes can be
found made from the round, shiny brown seed of a tropical bean, *Entada
scandens* (fig. 35). Also called a sea bean or matchbox bean, they were usu-
ally hollowed out and mounted with a silver lid. A silver shield-shaped
plaque, for engraved monograms, is often found in the center of one side,
hiding a dimple in the bean. Vegetable ivory, from the *Phytelephas macro-
carpa*, or Tagua nut, was also used for carved matchsafes.

Precious and semiprecious stones find their way into matchsafe design
in the form of carved hardstones, inlays, and inset gemstones. Hardstones
that required considerable time, effort, and skill to carve were highly
valued in matchsafe production for their inherent protective and aesthetic
qualities. Their ultra hard surfaces and rich hues could not be duplicated
by any other single material. Perhaps the ever-cool surfaces also seemed

especially appropriate for the storage of such dangerously flammable substances. Rich green nephrite, or jade, a favorite material of Fabergé and other Russian jewelers, was used for match containers made throughout Europe (see page 34 top left). Fine-grained agates with bold banded patterns were carved and mounted with silver lids (see page 34 top center).

Ivory, bone, shells, mother-of-pearl, lacquer work, horn, tortoiseshell, and animal hides are some of the other organic materials embraced by makers of pocket matchsafes. Ivory from elephant tusks was esteemed for its density and subtle grain patterns. Whole shells were sometimes hollowed out and mounted with silver to form match containers. Mother-of-pearl could be utilized as a veneer or inlay (see page 34 bottom left). Some Russian matchsafes were made of lacquer work, based on a substance derived from secretions of the insect *Coccus lacca*. Detailed painted decorations were a hallmark of these finely crafted boxes (fig. 36). Matchsafes made from sections of deer antler were popular in the Germanic countries and in Britain (see page 34 bottom right). Piqué work, made of tortoiseshell inlaid with gold or silver decorations, a technique used widely in eighteenth-century snuffboxes, continued to be popular for match cases (see page 34 bottom center).

Another material carried over from the production of French eighteenth-century boxes and cases was shagreen, made from the granulated skin of sharks or rays, often dyed a greenish hue. A French matchsafe veneered with shagreen, from about 1910, retains the traditional snuff-box form, with its opening on the upper broad flat side (see page 35 bottom left). Cowhides and other leathers were used for matchsafes shaped like miniature library volumes. In the United States, leather-covered matchsafes with pyrographic decoration, or branded designs, were especially popular in the early 1900s, and often featured rustic scenes and Native American motifs. A shamanlike assortment of other animal relics was incorporated into matchsafe design, including alligator skins, tiger teeth, and monkey paws.

Some of the most innovative matchsafes were those that utilized the era's newest materials and technologies. In 1839 Charles Goodyear revolutionized the rubber industry with his invention of vulcanized rubber—hard, pliant, and resistant to heat and cold. Known as vulcanite or ebonite, this improved rubber formula was being molded and carved into small match containers by at least the 1870s (see page 34 top right). Some dark brown or black vulcanite matchsafes are marked "New-York Hamburg G.W. Co.," others "Hannov G.K.C., Hannover," for two German rubber companies. Many vulcanite matchsafes have molded decoration with

36

Matchsafe made of lacquer, late
19th century, unidentified maker's
mark, Russia, lacquered wood,
enamel, sandpaper, 6.2 × 4 × 2 cm,
1978–146–558

37

Matchsafe made of vulcanite, early
20th century, probably United
States, vulcanite
6.4 × 3.4 × 1.4 cm, 1980–14–541

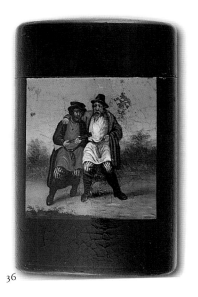

36

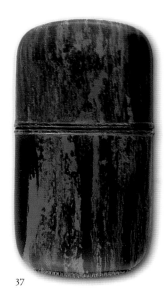

37

advertising for various kinds of companies. A rectangular vulcanite
matchsafe, with rounded contours and a cover that slides off, has striated
reddish coloration (fig. 37). Vulcanite match cases made for the British
market were ornamented with busts of Queen Victoria, King Edward VII,
or King George V. Book-form vulcanite matchsafes inscribed "Feu"
(French for fire) or showing an image of Vulcan, the ancient Roman god
of fire, were also popular.

Early forms of synthetic plastics—which first appeared in the late nine-
teenth and early twentieth centuries—were also eagerly adopted by
matchsafe manufacturers. Celluloid, developed from processed plant
fiber in 1869, was first used as a substitute for ivory, amber, and tortoise-
shell. Since early versions were highly flammable, its use as a container
for friction matches was limited, but it does show up extensively in the
form of printed covers for advertising matchsafes, like the kind first man-
ufactured around 1900 by Whitehead & Hoag (see fig. 69). Bakelite,
invented in 1907 by Leo Baekeland, was the first completely synthetic
plastic. It was initially used for small molded objects, and later for radio
housings and other household objects and appliances. Early Bakelite
tended to be dark and somewhat brittle. Though not used widely in
matchsafes and often difficult to identify with certainty, some Bakelite
matchsafes do exist.

Chapter Four

Beyond the Box

Matchsafes required sturdy walls, a secure lid, and a rough striking surface to protect against accidental ignition and to allow light on demand. Outside these prerequisites, however, there were practically no limits to the shapes and workings of matchsafes beyond the imaginations of their designers, inventors, and manufacturers. From basic box to the most unlikely forms, the morphology of matchsafes is one of their most intriguing and delightful aspects.

Pocket-sized matchboxes made of thin wood chip or cardboard were produced in quantity early on, but they were neither especially safe nor aesthetically pleasing for those who could afford more decorative cases. Eighteenth-century snuffboxes—many of them highly ornate and made of the most precious materials—may have been the inspiration for some early decorated pocket matchsafes (fig. 39). Palm-sized, generally rectangular in form, and with a lid hinged along one long side, the snuffbox form needed only the addition of a striking surface.

The size of pocket matchsafes is fairly consistent, with two basic types. Cases designed to hold wax vestas, popular in Britain, tend to be slightly smaller, usually measuring about one and a half inches in length. Those made to hold larger wooden friction matches, used more commonly in the United States, tend to be at least two and a half inches long. Most matchsafes were deep enough to accommodate from one to three rows of matches.

A small socket was incorporated into many early matchsafe designs, usually located on the top surface, into which a match could be set once it was lit, creating a miniature lantern (fig. 41). This feature was especially useful for melting sealing wax or lighting a cigar, when a flame was needed for a sustained period of time. Another feature that provided an extended flame for matchsafes was the tinder cord, a long rope woven of cotton or other fiber, housed inside the case (fig. 40). Rolled out by means

Opposite

Detail of figure 45

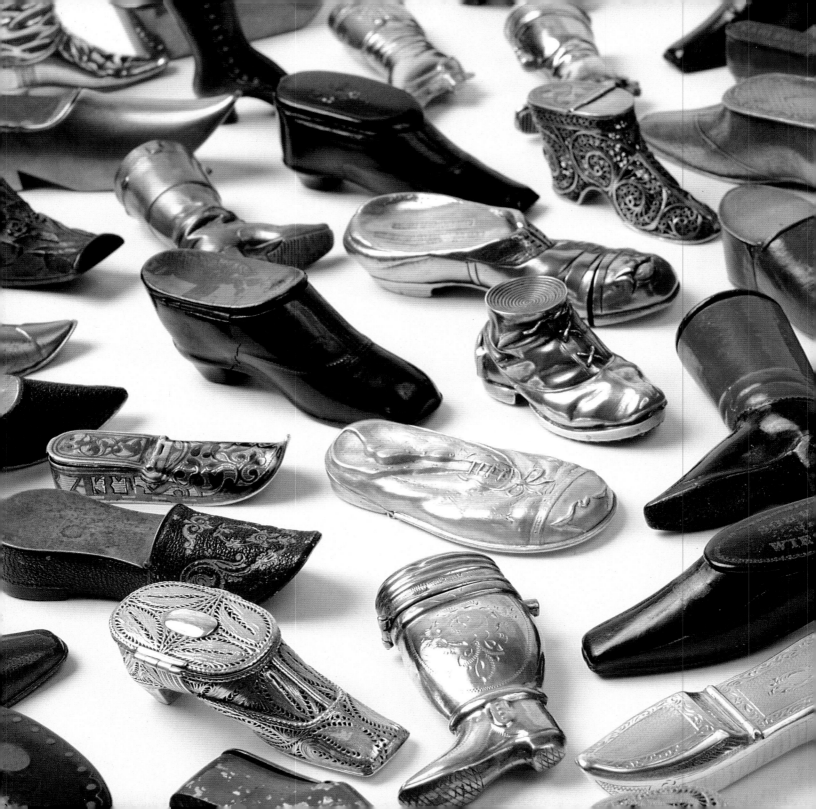

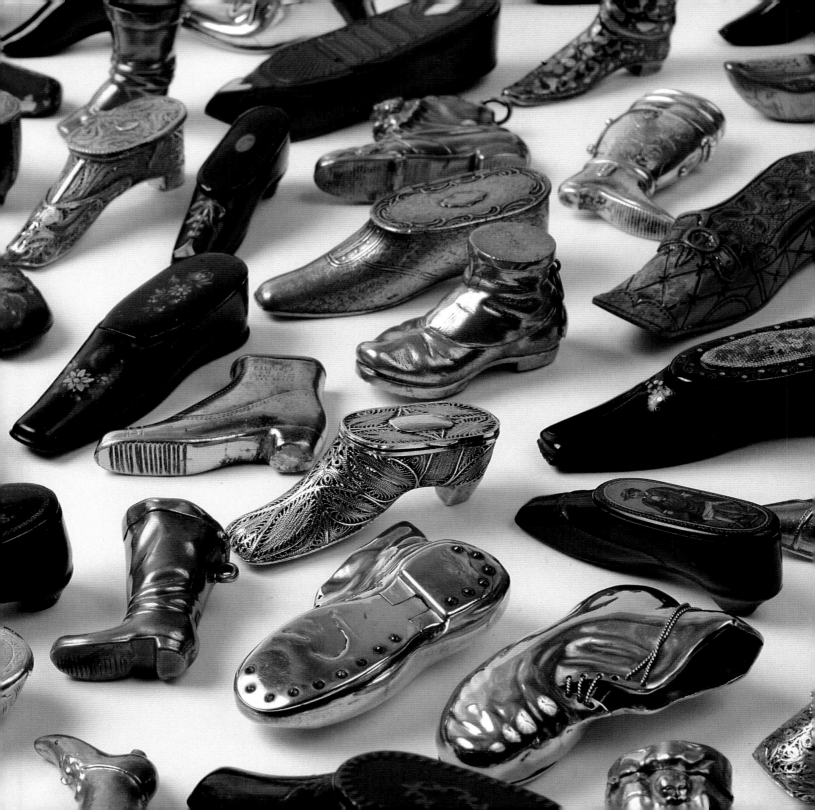

39

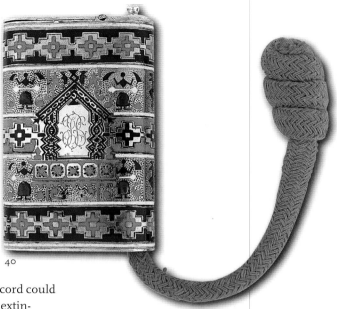

40

of a little wheel or drawn out with an attached hook, the tinder cord could be lit with a match and held aflame for as long as needed, then extinguished and rehoused in the case. Tinder cords remained popular for use in lighting cigars or pipes throughout the age of matchsafes.

The first U.S. Invention Patent registered for a pocket matchsafe, in 1858, was for a self-igniting model that ejected one match at a time. Many other self-igniting designs followed, including another patented matchsafe from 1889 (fig. 42), where matches drawn out through a narrow opening passed against a rough surface, lighting them automatically. The patent brief stated that the matchsafe could be fitted with a cover, it could be sized to fit one or more rows of matches, and it could be made of brass or another metal or of molded hard rubber.

Most pocket matchsafes were carried in men's vest pockets. Some cases were curved gently to fit snugly against the body. British models usually included an attached ring for securing to a watch chain. There were also matchsafes that were set on a leather band, like a wristwatch, for even easier access to a light. Patent records document other inventive ways for carrying matches close at hand, including a "match lighting attachment to hats," a leather "garment match-pouch" that could be buttoned to the inside of a jacket, and matchboxes that attached to bicycle frames. Another popular option was a small container built into the head of a walking stick.

Stylish ladies, freer from tobacco's rule but sometimes needful of a match at hand, carried pocket matchsafes less frequently than men and

generally stashed them in purses. Another convenient spot for match
keeping was on chatelaines, or belt attachments, accessories that were
popular from the 1890s through the First World War. Matchsafes were
standard equipment for nurses' chatelaines, outfitted with thermome-
ters, notepads, scissors, and copious other implements. A ring or chain
attachment was needed for securing a matchsafe to a chatelaine. Other
matchsafes with pin fastenings, like a heart-shaped box engraved "Etta,"
could be secured to a bodice (fig. 44).

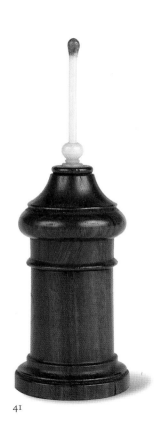

41

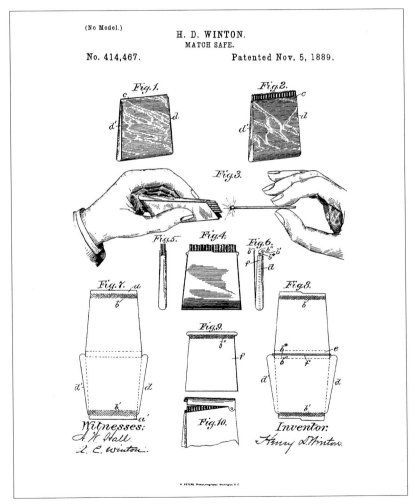

42

43

One of the most ingenious sets of variations in matchsafe design was in their opening devices. The first pocket matchsafe granted a design patent in the United States, in 1857, had an opening in the form of a sliding drawer. Other early matchsafes opened wide along one side like snuff boxes. Most often, box lids tended to separate about one quarter to halfway down the long side, and open by means of sliding off or being hinged at one side, or by releasing a spring-loaded device. There were also matchsafes with trick or puzzle openings, like some of the Scottish wooden boxes, "purse" openings with clasps to be pinched firmly, and "knapsack" openings where the lid folded down over the base. Pivot-type openings were used on both inexpensive matchsafes with advertising decoration and elegant silver models (fig. 45). Aperture openings, like the devices on cameras, are found on match cases shaped like bottles or flasks. Sliding tambour doors, made of wood, ivory, or metal, secured the contents of other matchsafes (fig. 43).

Pocket matchsafes designed as multipurpose containers abound. An early box patented in 1876 had separate compartments for holding matches, stamps, and straight pins. Other matchsafes incorporated additional compartments for storing small items like coins, train tickets, pencils, and toothpicks. A matchsafe patented in 1880 doubled as an ashtray for a cigar and featured a pronged holder where a cigar could be set in between puffs. Cigar cutters and compartments for storing cigarettes were other devices popular on matchsafes. An elegantly engraved silver matchsafe made in Birmingham has a matching case attached for stowing a cigarette holder (fig. 46).

For travelers, pocket matchsafes equipped with candles guaranteed a light to read by, and match cases in the form of clocks and calendars helped ensure punctuality (fig. 47). A patented matchsafe with a mouse-

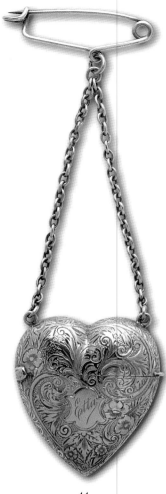

44

43

Matchsafe with tambour-style opening, late 19th century, Europe, ivory, wood, canvas, brass, 3.7 × 6.4 × 1.3 cm, 1980-14-1345

44

Matchsafe in the form of a heart with attached chain and pin, 1897–98, unidentified maker's mark, Birmingham, England, silver, 4.7 × 4.4 × 1.5 cm, 1980-14-1385

45

Matchsafe with diagonal opening,
c. 1875, Tiffany & Company, New
York, silver, 6.5 × 3.3 × 1.5 cm,
1978–146–370

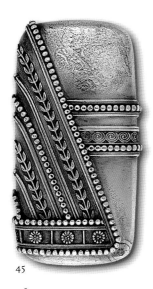

45

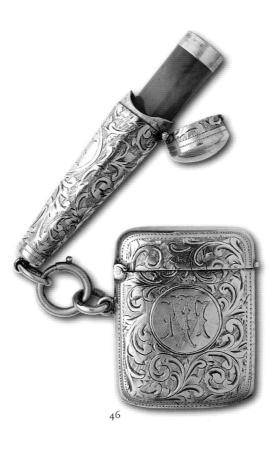

46

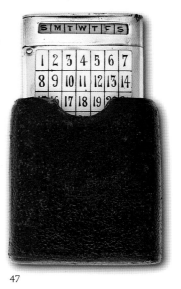

47

46

Matchsafe with attached case
for cigarette holder, 1903–4,
unidentified maker's mark (R. P.),
Birmingham, England, silver,
plastic, gold, 4.8 × 3.7 × 1 cm,
1978–146–795a/c

47

Matchsafe with perpetual calendar,
1887–88, unidentified maker's
mark (L. E.), Chester, England,
silver, enamel, bone, leather case,
4.5 × 4 × 1 cm, 1980–14–207

trap attachment may have been a comfort in uncertain sleeping quarters away from home. Whistles, pen knives, and corkscrews were other popular components on pocket matchsafes. Several patented matchsafes contained secret compartments for photographs of loved ones. The photo was usually revealed when a false side panel dropped away by releasing a hidden mechanism just inside the lid. Matchsafes with built-in sealing wax reserves and a personal seal were used both on the road and at home.

Waterproof match cases designed for use by hunters, campers, and soldiers at around the turn of the twentieth century are still in use today. An especially enduring pocket model was introduced in 1900 by Webster L. Marble of Gladstone, Michigan, and is cylindrical with a tight screw-top lid. Although waterproof and windproof, "NATO approved" survival matches are advertised on the Internet today, waterproof match cases continue to be listed as essential equipment for Boy Scout backpackers and other outdoors enthusiasts.

Among the most fanciful pocket matchsafes are the figurals, with their forms based on animals, vegetables, all kinds of man-made objects, and wild figments of the imagination. Popular shapes for these kinds of matchsafes were human heads and portrait busts of prominent persons, including the heads of idealized Egyptian goddesses and handsome youths. Matchsafes were also modeled after body parts or articles of clothing, such as hands, gloves, torsos, legs, hats, belts, and trousers (fig. 48). Man's best friend was the inspiration for many cases. Cats, horses, fish, frogs, birds, insects, and imaginary beasts such as dragons and demons also manifested themselves in match boxes.

Hundreds of pocket matchsafe designs were modeled on other types of containers. Matchsafes mimicked tiny valises and other traveling bags, camera cases, purses, baskets, bottles, barrels, mailboxes, coffins, and outhouses. An intriguingly large assortment was fashioned after boots and shoes, not only decorative objects of fashion but also ancient amuletic forms. These include elaborate silver filigree slippers, papier-maché high-tops with mother-of-pearl inlays, carved wooden sabots, and boots lined with painted leathers. Artful enameled decorations transformed rectangular match cases into miniature books, magazines, calling cards, and train tickets. Some matchsafes had game counters and dice built in to them; others were made in the shape of dominoes. The form of horseshoes and other lucky charms transformed functional containers into deeply personal talismans.

48

Top. Matchsafe in the form of a woman's head with exotic head-dress, late 19th century, possibly United States, plated brass, 4.7 × 4.3 × 3.7 cm, 1982–23–612

Center (above). Matchsafe in the form of a corseted female torso, late 19th century, Europe, brass, 4 × 3.5 × 2 cm, 1982–23–148

Center (below). Matchsafe in the form of a pair of bloomers, late 19th century, Europe, plated brass, 5.6 × 3.8 × 2.4 cm, 1982–23–72

Center left. Matchsafe in the form of a clenched hand, late 19th century, Europe, brass (originally plated), 5.1 × 2.5 × 2 cm, 1982–23–632

Center right. Matchsafe in the form of a leather glove, late 19th century, Europe, brass, leather, 6.1 × 2.5 × 1.3 cm, 1978–146–600

Bottom left. Matchsafe in the form of woman's leg with shoe and stocking, late 19th century, Europe, plated brass, leather, 5.6 × 2.6 × 1.4 cm, 1982–23–1346

Bottom right. Matchsafe in the form of a woman's leg, late 19th century, Europe, brass, 7.7 × 2.7 × 1.8 cm, 1982–23–1343

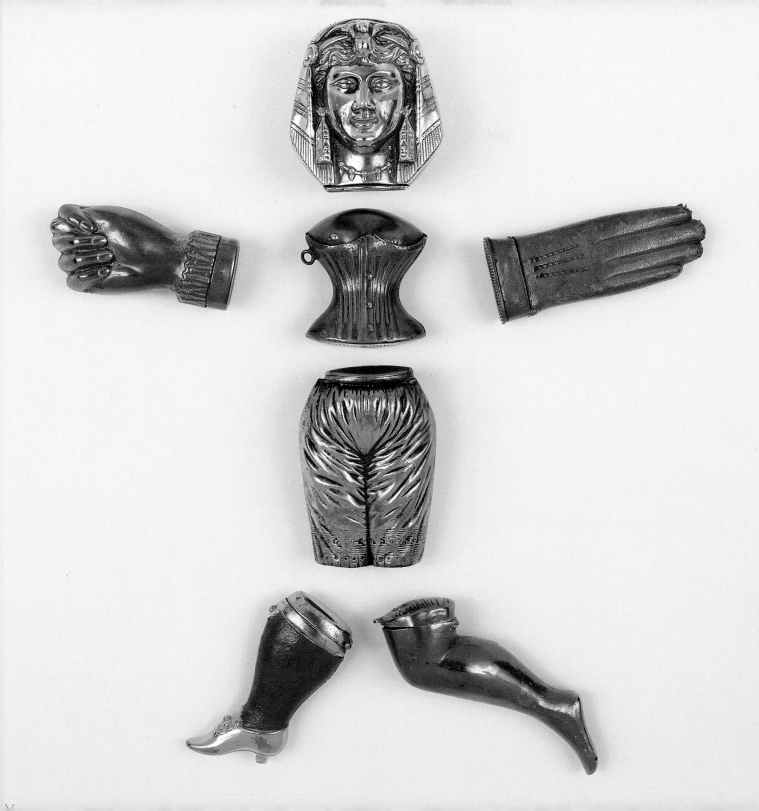

Stylish Accessories

The history of matchsafe design closely parallels the development of tastes in European and American high-style design and decoration. Matchsafe designers followed wider trends in the fine arts, in interior design, and in the decorative arts, particularly in silver and jewelry design. Matchsafe patrons sought fashionable accessories that kept up with the latest fashions while satisfying practical needs and providing aesthetic pleasures.

When matchsafes came on the scene in the second half of the nineteenth century, academic paintings dominated the Paris art salons, and the decorative arts were governed by an eclectic range of historical revival styles and exotic tastes. The annual art salons featured giant canvases painted with mythological subjects, heroic figures, historical costume dramas, and sentimental genre scenes of everyday life. Female nude and seminude figures were popular, often modeled on those painted by Raphael, Titian, and other great Renaissance artists. The subject matter of many of these academic paintings, notably the voluptuous female figures, found their way into matchsafe design, either in the form of relief ornament or as painted or printed enamel decoration (fig. 51). Several compositions by the popular French academic painter Adolphe-William Bouguereau, especially his scenes of scantily clad nymphs and fleshy cherubs, were widely copied by matchsafe designers. In 1893, the New York silversmiths William B. Kerr & Company advertised their matchsafes as "Bouguereau's Great Masterpieces in Silver." *The Storm*, a painting by Pierre-Auguste Cot, depicting a young couple dressed in filmy drapery fleeing an impending squall, was reproduced by many different American matchsafe manufacturers from the time it was acquired by New York's Metropolitan Museum of Art in the 1880s through the first decade of the 1900s (figs. 52, 53).

High styles in interiors and the decorative arts during the middle years

Opposite

Detail of figure 60

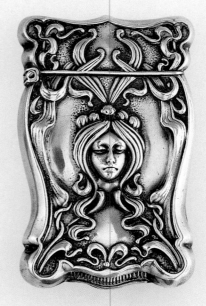
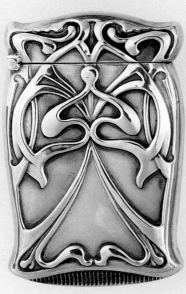
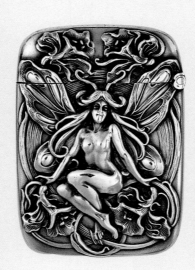
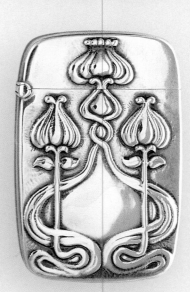

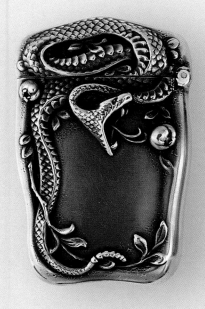
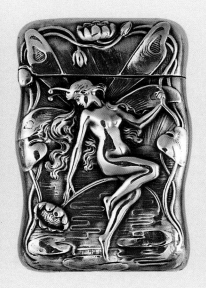
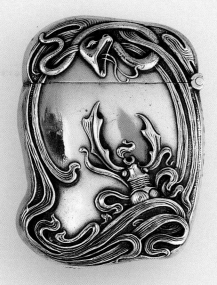
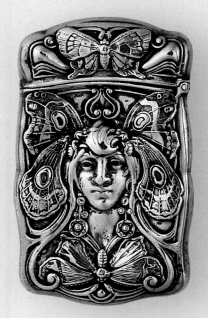
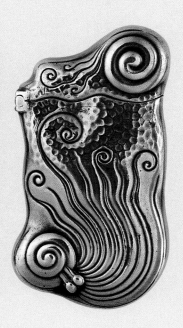
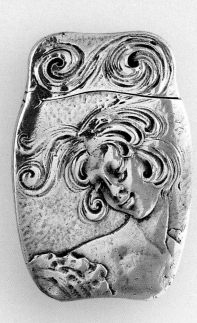

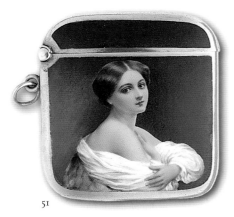

51

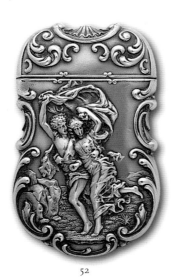

52

53

of the nineteenth century were mainly a melange of reconstituted historical styles from Europe's past, spiced with exotic influences from China, Japan, the Middle East, and other foreign lands. A major forum for the popularization of new styles was the World's Fairs, starting with the first one in London in 1851, known as the Crystal Palace Exhibition. Here were exhibited contemporary examples of English pottery made in the Renaissance style, Dutch metalwork copied from medieval designs, and new French furniture that adapted eighteenth-century models from the court of King Louis XV.

Likewise, high-style matchsafe designs also looked to the past for inspiration. Some were modeled on eighteenth-century gold snuffboxes made to hold aromatic tobacco mixtures. Others were ornamented with robust,

54

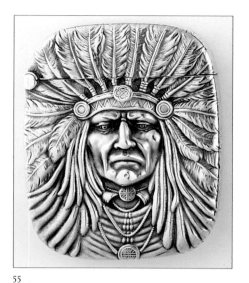

55

54

Matchsafe with Egyptian motifs,
c. 1900, probably Europe, brass,
4.8 × 3.7 × .9 cm, 1978–146–611

55

Matchsafe depicting a Native
American man in feathered head
dress, c. 1904, Unger Brothers,
Newark, New Jersey, silver,
6 × 4.7 × 1.3 cm, 1978–146–282

Opposite

Detail of figure 50, top left

leafy scrollwork popular during the Baroque era. Matchsafes made in the
Scandinavian countries often featured motifs derived from Viking times,
and some particularly fine Russian enameled matchsafes were based on
traditional metalwork and textile designs (see fig. 40). Ancient Egyptian
gods, pyramids, and hieroglyphs turn up on matchsafes made in Paris,
London, and New York (fig. 54). In the United States, matchsafe designers
drew on Native American themes. Gorham, Unger Brothers, and several
other manufacturers featured matchsafes with striking images of warrior
chiefs in full feathered headgear (fig. 55).

Since ancient times when luxurious textiles, porcelains, lacquers, and
other goods from the East first reached Europe through early trade routes,
Westerners have been fascinated with these exotic materials and their
unfamiliar decoration. In the late nineteenth century, fine enameled and
silver filigree matchsafes, made for export, arrived from China.
Matchsafes that were outstanding examples of traditional Japanese metal-
working techniques arrived in quantities after trade opened up with Japan
in the 1850s. In addition, European and American matchsafe designers
devised their own variations on Chinese and Japanese decorative themes.
Scenes of Turkish harems, often based on popular salon paintings, and
colorful geometric patterns recalling exquisite tilework compositions
from Middle Eastern architecture are found on the most fashionable
European matchsafes from the late nineteenth century.

The arts and crafts movement, an important force of reform in interior design and the applied arts during the second half of the nineteenth century, especially in England and America, also left its mark on matchsafe design during these years. English designer and theorist William Morris, in reaction to the advancing mechanization of industry and the tired rehashing of previous decorative styles, called for a return to hand craftsmanship and a fresh look at forms from nature. Matchsafe designs influenced by the arts and crafts movement often feature hand-hammered surfaces or, sometimes, surfaces that are purposefully made to look as if they were finished by hand. Some especially fine silver matchsafes made by Tiffany & Company, Gorham, George Shiebler, and other silversmiths combine hand-hammered surfaces with delicate leaf and animal motifs borrowed from traditional Japanese design (fig. 56).

Other matchsafes inspired by the arts and crafts movement followed silver designs by English theorist C. R. Ashbee, founder of the Guild and School of Handicraft, and Archibald Knox, a prominent silversmith who worked for the fashionable London department store Liberty's. These matchsafes, from the 1900s and 1910s, usually feature plain surfaces with restrained enameled decoration. The enameled decoration is often in the form of geometric configurations based on traditional Celtic knot patterns or of highly stylized floral or plant forms (fig. 57).

The aesthetic movement, when it came to the fore in England and America in the 1870s, was a major influence on the decorative arts in general and also on matchsafe design. As popularized by Oscar Wilde, the aesthetic movement advocated "art for art's sake," and rejected the "Philistine" tastes of previous decades. Aesthetic-style interiors stressed artistic arrangements of furniture and decorations to create a light, airy feeling that contrasted with the dark, ponderous forms of many historical revival styles. Matchsafes in the aesthetic style often feature asymmetrical compositions with overlapping panels of fans, flowers, birds, and other motifs (fig. 58). Japanese decorative patterns or plant and animal motifs were also popular on aesthetic-style matchsafes, following the Anglo-Japanese style of silver, furniture, and other interior furnishings, as promoted by English designer E. W. Godwin and others.

When the World's Fair opened in Paris in 1900, a new decorative style was sweeping through European architecture, graphic design, and the applied arts. Coined "art nouveau," after the title of Siegfried Bing's fashionable shop that had opened in 1895 in Paris, this new style was defined by long, sinuous curves, mysterious female figures, and a predilection

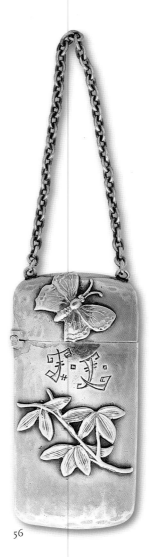

56

56

Matchsafe with attached chain,
c. 1885, George W. Shiebler,
New York, silver, 6.5 × 3.1 × 1.5 cm,
1978–146–205

57

Matchsafe in the arts and crafts
style with Celtic knot motif, 1902–3,
for Liberty & Company,
Birmingham, England, silver,
enamel, 5 × 3.8 × 1 cm, 1982–23–122

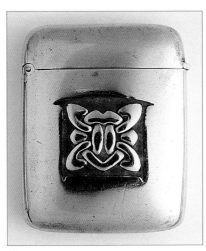

57

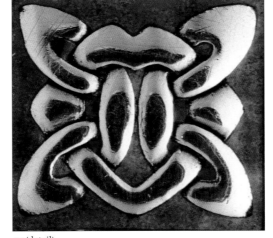

57 (detail)

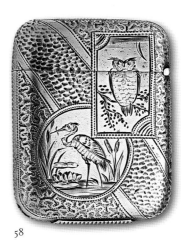

58

58

Matchsafe in the aesthetic style
with heron and owl, 1887–88, prob-
ably Sampson Mordan & Company,
London, also marked "H. Greaves,
Birmingham," silver, 5.1 × 3.9 × 1 cm,
1980–14–24

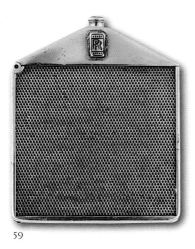

59

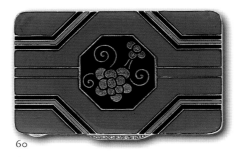

60

for insect forms and sea life. The art nouveau style seemed to blossom everywhere. A series of grand entrances for the Paris Métro, designed by Hector Guimard, took the form of arching whiplash curves in cast iron and glass. The Parisian jeweler René Lalique exhibited his jewelry at the 1900 World's Fair in a sensational booth faced with bronze grillework composed of figures that appeared half woman-half bird, suspended in a weblike frame. Inside his booth, Lalique displayed magnificent necklaces, brooches, tiaras, and other jeweled items ornamented with images of dreamy figures, melancholy landscapes, and fantastical anthropomorphic transformations—of men into plants and women into insects and birds.

The art nouveau style had a major impact on matchsafe design in the years around the turn of the century. An astounding number of matchsafe designs inspired by Lalique's moody female figures and naturalistic forms were produced by American and European manufacturers (see pages 54–55). Favorite designs included relief decoration of languid women with half-closed eyes and flowers woven into their hair, female masks framed by smoky streams of sinuous curves, and undine-like creatures or women with butterfly wings emerging shyly from lilypad ponds. Other watery decorative motifs included shells, seaweed, fish, and octopuses, whose long, fanning tentacles could be arranged in flowing art nouveau lines. Menacing serpent forms, echoing imagery favored by symbolist painters

59

Matchsafe in the form of a Rolls-Royce radiator grille, 1923–24, Birmingham, England, silver, enamel, 4.9 × 3.8 × 1 cm, 1978–146–98

60

Matchsafe in the art deco style with central floral motif, 1926–27, France, with London import marks, gold, enamel, diamonds, 3 × 4.6 × 1.8 cm, 1978–146–37

and poets in the early 1900s, were wrapped around matchsafes in artful coils.

Just as the use of pocket matchsafes was waning in the late 1910s, giving way to portable gas cigarette lighters, an important new decorative style was emerging in Europe. The art deco style, whose name derives from the international exposition of modern decorative and industrial arts held in Paris in 1925 (*L'Exposition Internationale des Arts Décoratifs et Industriels Modernes*), celebrated sleek modernist designs and abstract or machine-like motifs. Matchsafes shaped like radiator grilles from Rolls-Royce cars reflect the fascination with modern twentieth-century vehicles (fig. 59). Enameled cases featured colorful, stylized floral and geometric motifs (fig. 60). When matchsafes were retired from ladies' purses and gentlemen's pockets, art deco lighters, compacts, and cigarette cases carried on these same decorative treatments.

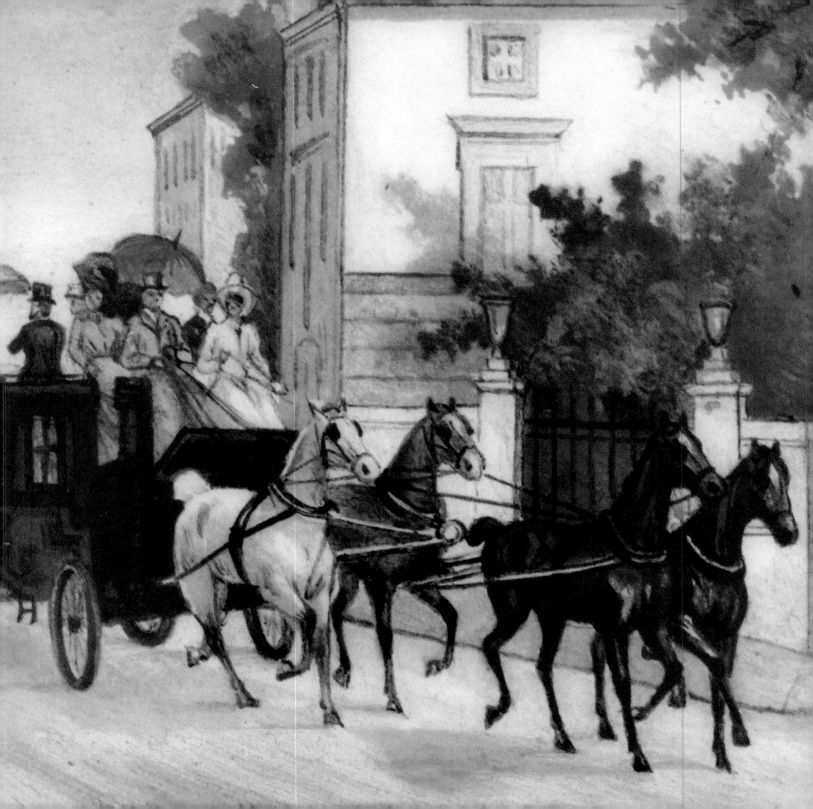

Mirrors of Daily Life

By their nature, pocket matchsafes were imbued with both personal intimacy and cultural immediacy. Used on a daily basis, they were carried close to the body and handled perhaps scores of times throughout a day while in transit, at work, or at play. Promoted commercially as novelty items featuring highly topical form and decoration, they were inexorably linked to contemporary preoccupations, pastimes, and other aspects of popular culture. They were virtual mirrors of daily life throughout the age of matchsafes.

Since pocket matchsafes were used primarily by men, their designs were predominantly male oriented. Women, however, were a favorite subject of decoration, ranging from artistic scenes of female nudes to popular images of alluring maidens to considerably more racy subjects. Academic salon paintings featuring female figures were reproduced as enameled compositions on many matchsafes. A common motif on American matchsafes was the Gibson Girl, a fashionable, self-confident young woman with swanlike neck and loose, upswept coiffure, as created by illustrator and ad man Charles Dana Gibson in the 1890s. Gibson Girls stare dreamiliy into space or roll up their sleeves and play tennis or golf on matchsafes made in the United States from around 1895 to 1915.

Cancan dancers, cabaret singers, and other showgirls were also popular subjects on decorated pocket matchsafes. The second half of the nineteenth century witnessed the blossoming of Parisian nightlife. The Chat Noir, established in 1881, and the Moulin Rouge, featured in paintings by the artist Henri Toulouse-Lautrec, were among the many nightclubs and cabarets that opened their doors. French silver matchsafes featured enameled decorations of high-kicking cancan dancers (fig. 63). A large number of brass boxes were made with enameled ornamentation featuring women in coquettish poses and in varying degrees of undress, often

Opposite

Detail of figure 62, bottom left

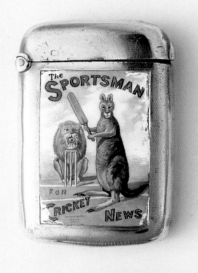

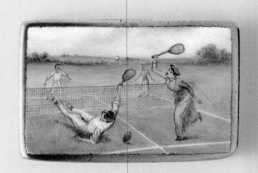

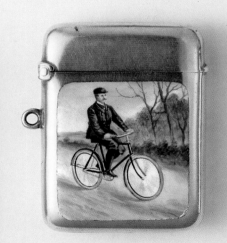
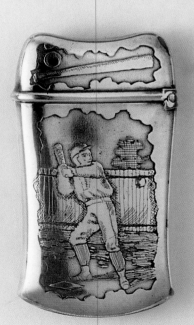

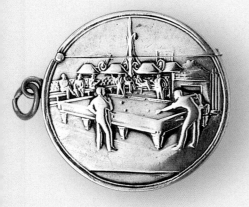
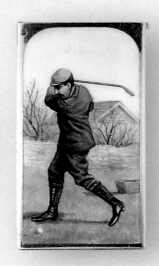
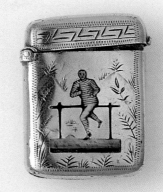
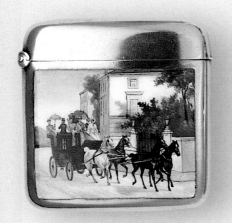
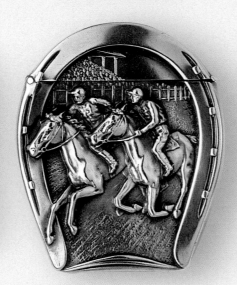
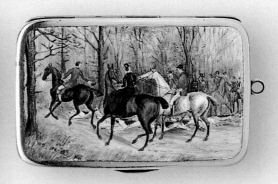

shown in slightly naughty comic vignettes. Such scenes were sometimes painted in two parts, with a second, more erotic scene on the inside cover of the box.

The subject of women was sometimes associated with other gentlemen's "vices"—smoking, drinking, gambling, and general high living. An unmarked American silver matchsafe of this type has relief decoration in a schematic pattern of a champagne glass, a liquor bottle, a smoking cigar, a match container, a succulent roast turkey, and an alluring female face emerging through a smoky mist. Playing cards, horseracing, and other gambling motifs show up frequently as decorative devices, as evidenced on an English box with fine enameled decoration showing five playing cards (fig. 64).

Thousands of matchsafes featuring sports and outdoor activities popular in the years around the turn of the century were created in the United States, Britain, and other European countries. Some were made in the shape of sport-related artifacts like rugby balls, footballs, golf balls, and horseshoes (page 66 top center). An American novelty matchsafe takes the form of a fishing reel, wound with hook, line, and sinkers (page 66 bottom left). Other cases were painted with detailed enameled scenes of fishing and hunting (page 67 bottom right). Billiards, bowling, table tennis, and boxing were other popular games represented on matchsafes (page 67 top left).

Many of the sports and games featured in matchsafe design were newly introduced or just then gripping the popular imagination. Cricket and golf, which had been played in Britain for many years, gained new momentum as highly fashionable activities in that country around the middle of the nineteenth century. An English matchsafe issued by *The Sportsman*, ornamented with a lion and kangaroo playing cricket, commemorates a British-Australian match from 1899 (page 66 top left). By the turn of the century, when golf had become firmly entrenched in British and American high society, matchsafes frequently appeared ornamented with men—and sometimes even ladies—club in hand, in full swing (page 67 top center). The emergence of modern lawn tennis in the 1870s is evidenced by a game of mixed doubles on an English enameled box (page 66 top right). Baseball, America's new "national pastime," was the inspiration for matchsafes like the one showing a batter poised to receive a pitch, with a bat and ball motif on its lid (page 66 bottom right).

Pocket matchsafes with traditional scenes of coaching and horseracing were joined by newer themes like bicycle riding, motor car touring, and flying machines, all inventions of the age of matchsafes. A matchsafe

61 *Page 66*

Top left. Matchsafe with cover of *The Sportsman* magazine, 1899–1900, unidentified maker's mark (W. N.), Chester, England, silver, enamel, 5.4 × 3.7 × 1 cm, 1982–23–40

Top center. Matchsafe in the form of a British football, on reverse inscribed "Strike boldly, then your light will shine clear, Affly." 1905–6, Sampson Mordan & Company, Chester, England, silver, 4.4 × 5.7 × .6 cm, 1978–146–157

Top right. Matchsafe with tennis players, 1891–92, John Millward Banks, Birmingham England, silver, enamel, 3.4 × 5.4 × 1 cm, 1978–146–399

Bottom left. Matchsafe in the form of a fishing reel, late 19th century, United States, silver, 6 × 3.2 × 1.3 cm, 1980–14–486

Bottom center. Matchsafe with bicyclist, 1906–7, unidentified maker's mark (R. C.), Birmingham, England, silver, enamel, 5 × 4.3 × 2.2 cm, 1978–146–172

Bottom right. Matchsafe with baseball player, c. 1890, United States, silver-plated metal, 6.8 × 3.4 × 1 cm, 1978–146–450

62 *Page 67*

Top left. Matchsafe with billiards players, 1907–8, unidentified maker's mark (A & B), Birmingham, England, silver, 4.5 × 5.7 × .8 cm, 1982–23–92

Top center. Matchsafe with golfer, 1891–92, Sampson Mordan & Company, London, silver, enamel, 5.6 × 3 × .9 cm, 1978–146–168

Top right. Matchsafe with rugby player, late 19th century, possibly Sampson Mordan & Company, England, silver–plated metal, enamel, 4 × 3 × 1 cm, 1978–146–407

Bottom left. Matchsafe with coaching scene, late 19th century, unidentified marks, probably Germany, silver, enamel, 4.7 × 4.7 × 1.1 cm, 1978–146–389

Bottom center. Matchsafe in the form of a horseshoe, c. 1900, Battin & Company, Newark, New Jersey, silver, 6.2 × 5 × 1.8 cm, 1978–146–183

Bottom right. Matchsafe with hunting scene, 1888–89, probably George Heath & Co., London, silver, enamel, 3.8 × 6.1 × 1.2 cm, 1978–146–165

63
—
Matchsafe with cancan dancer, late 19th century, unidentified mark, France, silver, enamel, 4.8 × 3.3 × 1 cm, 1978–146–259

64
—
Matchsafe with playing cards, 1885–86, Cornelius Saunders & Frank Shepherd, London, silver, enamel, 2.4 × 4.6 × 1.1 cm, 1978–146–228

63

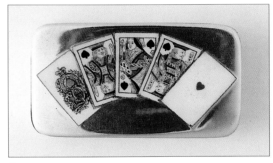

64

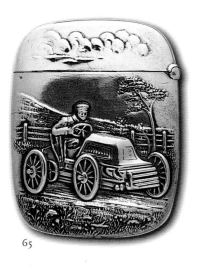

65

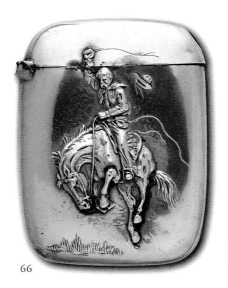

66

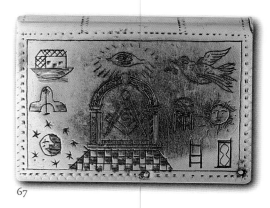

67

with an enameled scene of an elegant coach and four is typical of British and European models from around the turn of the century (page 67 bottom left). On a case made by Battin & Company, a horseshoe provides a framing device for two jockeys tearing around a track on their racehorses (page 67 bottom center).

The bicycle craze that launched the annual Tour de France race in 1903 inspired many matchsafes featuring male or female riders in the early years of the twentieth century (page 66 bottom center). In the same year, Orville and Wilbur Wright flew the first powered airship at Kitty Hawk, North Carolina. Match containers made around the same time feature biplanes resembling the one used by the Wrights in their landmark flight. Early experiments in automobiles during the 1880s and 1890s, by Henry Ford, Karl Benz, and others, were celebrated in matchsafes ornamented with motor cars thundering down country lanes (fig. 65).

Other images from popular culture that were frequently incorporated into matchsafe design of the period include scenes of cowboys, Native American Indians, and other motifs from the American Wild West. A cowhand taming a bucking bronco is featured on an American case from around 1900 (fig. 66). Such scenes were valued not only as emblems of manly pursuits, but also as poignant reminders of an era already beginning to fade into history.

Ornamental matchsafes from the turn of the century mirror the popularity of fraternal organizations, men's clubs, and school associations.

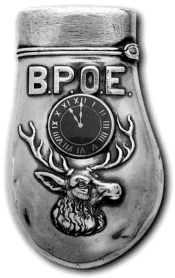

68

65

Matchsafe with motor car, c. 1902,
United States, silver,
5.8 × 4.3 × .9 cm, 1980–14–97

66

Matchsafe with cowboy on bucking
horse, c. 1900, United States, silver,
6.4 × 4.7 × 1.2 cm, 1978–146–1320

67

Matchsafe with Masonic symbols,
c. 1900, United States, plated
metal, 4.1 × 5.7 × 1.2 cm,
1980–14–1283

68

Matchsafe with Order of Elks
motifs, patented 1899, Simons
Bros. & Company, Philadelphia,
silver, enamel, 6.1 × 4 × 1.7 cm,
1978–146–1170

These groups played important roles as social, philanthropic, and spiritual centers, especially in the United States, where a rapidly growing population was spreading clear across the continent. Matchsafes are rich in the symbolic ornament and insignia of such organizations. Members of the Freemasons, an organization with medieval origins, carried pocket matchsafes ornamented with masonic symbols. An American box, inscribed with the name "Hugh Borland" on one side edge and, on the lid, lodge "No. 406," has naive engraved decoration on its front and back of masonic motifs like the square and compass, the all-seeing eye, a blazing sun, a globe, and moon and stars (fig. 67).

Among the many men's associations that came into being during the last half of the nineteenth century were the Benevolent and Protective Order of Elks, founded in New York City in 1868. Matchsafes abound with ornamentation based on the B.P.O.E. initials, the logo of an elk's head, and a clock set at the hour of eleven, the designated time for a ritual Elks toast. An especially popular silver case was made in the shape of an elk's tooth, with a blue enameled clock dial (fig. 68). Many matchsafes are found with logos for other organizations such as the Fraternal Order of Eagles, the Knights of Pythias, and the Independent Order of Odd Fellows. School-related themes were also popular, with university seals and college mascots figuring prominently. A popular matchsafe model was ornamented with a school seal on one side and, on the other, a rowdy drinking scene and books languishing in cobwebs.

Miniature Billboards

An important secondary function of pocket matchsafes, after providing secure, portable housing for lights, was in displaying advertising copy, much the same way that paper matchbook covers still do at the dawn of the twenty-first century. The age of matchsafes saw tremendous growth in industry and commerce in the Western world. Pivotal inventions such as the sewing machine, automobiles, and canned food created huge new industries. Emerging businesses were aided by innovations like typewriters, telephone systems, and skyscrapers. By 1900, advertisements in the form of company logos and promotional messages permeated the visual culture of the day. Even matchsafes had become miniature billboards for manufactured products, service industries, and other self-publicizing organizations (pages 74–75).

Matchsafes featuring advertising copy were some of the most common types of pocket cases produced from 1900 to 1920. Most were inexpensive, made of plated metal with stamped or printed designs. Especially popular were the plain rectangular metal boxes wrapped with celluloid covers printed with company logos and promotional copy. Made by Whitehead and Hoag, J. G. Mergott Company, August Goertz & Company, Bastien Brothers, and other matchsafe and novelty manufacturers, this type of case was produced by the thousands. They document the lively mix of goods and services appearing at that time, and are wonderful palm-sized records of commercial graphic design from the period.

A pocket matchsafe illustrating a lady at work cleaning her ornate kitchen stove promotes Fire King Gas Ranges as "low in price," and assures consumers that "a match is all the kindling required" (see pages 74–75 for this and following matchsafes). Green's Lawn Mowers, "Hundreds of thousands in Use," are advertised by Thomas Green & Son, Ltd., of London, on a matchsafe made by Whitehead and Hoag showing a

Opposite

Detail of matchsafe made for S. J. Moreland & Sons, Gloucester, England, 1900–10, Whitehead & Hoag Company, Newark, New Jersey, plated metal, printed celluloid, 5.7 × 3.6 × 1 cm, 1980–14–1418

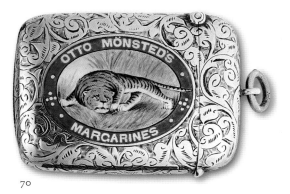

70

push mower cutting a swath through a grassy English countryside. A pocket matchsafe emblazoned with a cutaway diagram of rubber plumbing fixtures was commissioned by the Climax Specialty Company, Seneca Falls, New York, "Inventors & Sole Manufacturers" of "Plumbers' Rubber Goods and Washers." The Amazon Café in Bridgeport, Connecticut, issued a matchsafe featuring its building facade on one side and on the other a logo of a mythological Amazon warrior on horseback, spear in hand, fighting an attacking lion. A magnificent steer's head crest is the focal point for the decoration of a matchsafe advertising the Molassine Company of London, manufacturers of horse food, cattle feed, dairy and pig meal, calf meal, and lamb food. Following the practice of the day, where sober advertising messages on one side were often matched with seemingly incongruous images on the flip side, the back of this box shows a voluptuous naked maiden serving a platter of Molassine to a rather contented looking hog.

Trade unions also issued matchsafes wrapped with celluloid covers featuring promotional images and slogans. These increasingly powerful organizations, many of them established in the last decades of the nineteenth century, lobbied for improvements in working conditions and the economic status of factory laborers. Advertisements promoting the purchase of union-made products were frequently carried on pocket matchsafes. A matchsafe commissioned by the United Hatters of North America features that union's logo and carries the motto "Buy no hat without this label." The National Union of the United Brewery Workmen of the U.S. commissioned matchsafes imprinted with their union label, proclaiming, "This label should be pasted on every package containing

71

72

beer, ale, or porter as the only guarantee that said package contains beverages produced by Union Labor."

Small boxes designed to contain and advertise a particular product sometimes incorporated a striking surface so that, once emptied, they could be reused as matchsafes. A printed tin box issued for Tetley's Teas has a grooved section on its bottom side for striking matches. A diminutive aluminum container stamped " 'His Master's Voice' Loud Tone Needles," originally designed to hold phonograph needles, was also made to be reused for matches. Other small boxes for products such as cocoa, razor blades, pen nibs, and tobacco products were similarly designed to have a second life as matchsafes.

Some companies commissioned special matchsafes made from more precious materials to promote their products. A silver matchsafe made in Birmingham, with elaborate engraved ornamentation, features an enameled plaque inscribed "Otto Monsted's Margarines" surrounding a crouching tiger (fig. 70). The Gorham Manufacturing Company fashioned a silver matchsafe for *Scribner's Magazine* that has the appearance of a tiny edition of that periodical (fig. 71). A silver Tiffany & Company matchsafe ornamented with a logo of an American Colonial soldier was made for the Continental Match Company.

Most creative and amusing of the advertising matchsafes were the cases made in the shape of the product being promoted. There are surprising shapes, like "The Boyer" pump issued by the Chicago Pneumatic Tool Company, as well as more regular forms. Clever trompe l'oeil effects abound, like the blackened barklike surfaces of the "Hemlock" log matchsafe commissioned by the Goodyear Lumber Company of

73

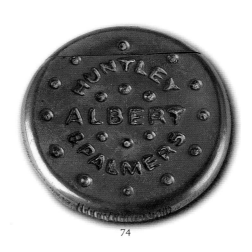

74

75

Buffalo, New York (fig. 72). Some promotional matchsafes were made of the same materials manufactured by the commissioning company. A matchsafe in the shape of a boot made of vulcanized rubber was issued by the Hood Rubber Company of Boston (fig. 73).

Food and beverage companies were big advertisers through the medium of matchsafes, many of which were designed in the form of the product. A round Huntley & Palmers "Albert" biscuit was replicated in brass for a series of promotional matchsafes (fig. 74). Other match containers were made in the shape of bars of Suchard chocolates. The largest segment of advertising matchsafes belongs to producers and retailers of beer, wine, and champagne. For them, match containers were made in the form of miniature bottles of ale, champagne bottles, liquor flasks, oak casks, and wooden crates (fig. 75). A matchbox simulating a basket of champagne bottles, marked Moët & Chandon, Epernay, has detailed painted decoration and molded basket weave surfaces (fig. 76).

Tobacco products, especially cigars, were also frequently advertised with matchsafes made in the form of the product. A match case shaped like a hand-rolled cigar, end clipped, bearing a label inscribed "Escepcional de la Espanola" is typical (fig. 77). Other cases take the form of a row of cigars

73

Matchsafe in the form of a boot inscribed "Compliments of Hood Rubber Company, Boston, U.S.A.," c. 1910, United States, vulcanite, 7.3 × 4.5 × 1.8 cm, 1978–146–596

74

Matchsafe in the form of a biscuit inscribed "Huntley & Palmers, Albert," c. 1890, Vienna, Austria, brass, 5.1 × 5.1 × 1.8 cm, 1978–146–17

75

Matchsafe in the form of a champagne bottle inscribed "Louis Roederere, Reims," c. 1890, France, plated metal, 7.8 × 2 × 2 cm, 1982–23–13

76

77

76

Matchsafe in the form of a hamper inscribed "Moët & Chandon, Epernay, M & C 4759," c. 1890, France, brass, enamel, 3.5 × 5 × 2.1 cm, 1978–146–216

77

Matchsafe in the form of a cigar inscribed "Escepcional de la Espanola," late 19th century, probably Europe, plated metal, enamel, 10.5 × 1.7 × 1.7 cm, 1978–146–254

banded together, or wooden cigar boxes ornamented with colorful manufacturers' labels (see page 15 top center and fig. 9). For products that were designed to vanish "up in smoke," a match container branded with a manufacturer's logo provided an enduring and remindful materialization.

Souvenirs and Commemoratives

The advent of mass tourism and the highly sentimental spirit of the Victorian era both made their mark on matchsafe design during the second half of the nineteenth century. At a time when vast new horizons were opening, matchsafes became souvenirs of dream destinations. They came to embody the zeitgeist of a society eager for heroes and striving to make sense of a rapidly changing world. Vast numbers of decorative match containers were designed to commemorate popular tourist destinations, special events, famous people, and personal sentiments (pages 82–83).

The creation and expansion of steam-powered railroads, underway in Europe and the United States by the 1830s, allowed previously inconceivable access to travel for thousands of middle-class citizens. Legions of tourists set out to experience the Grand Tour, an extended trip throughout Europe and the Near East previously available only to the wealthy classes. Others traveled to marvel firsthand at the natural wonders of the New World. Karl Baedeker launched his series of tourist guidebooks in 1829, and in 1841 Thomas Cook arranged his first public excursion. The Orient Express, carrying passengers from Paris to Instanbul in dizzying speed and luxury, made its first run in 1883. Jules Verne's 1872 novel, *Around the World in 80 Days*, captured the period's tremendous enthusiasm for travel.

Matchsafes soon joined scenic prints, local crafts, and other tangible mementos of a foreign visit as ornamental tourist souvenirs (fig. 80). A match container with inlaid decoration, inscribed Marienbad, would have served as a decorative memento from a visit to this old German/Czech spa town (see page 82 bottom left). A trip to Paris may have been commemorated by a matchsafe carrying an image of the Eiffel Tower, erected in 1889 and since then an icon of one of the world's most popular tourist destinations (see page 82 top left). An ancient Egyptian mummy, evoking the buried treasures of pyramids along the Nile, is the

Opposite

Detail of figure 78, top left

CARRICK CASTLE, LOCHGOIL.

Souvenir of DREAMLAND Coney Island N.Y.

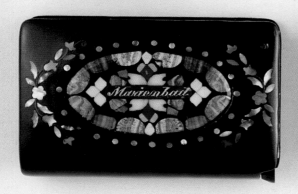

Marienbad

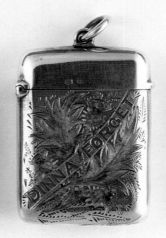

DINNA FORGET

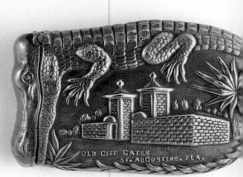

OLD CITY GATES, ST. AUGUSTINE, FLA.

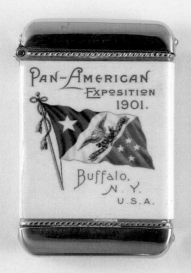

PAN-AMERICAN EXPOSITION 1901. Buffalo, N.Y. U.S.A.

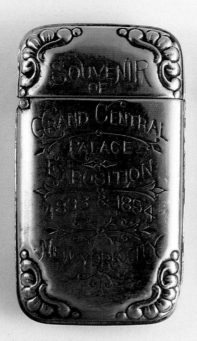

SOUVENIR OF GRAND CENTRAL PALACE EXPOSITION 1893 & 1894 NEW YORK CITY

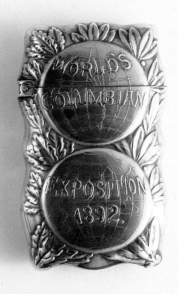

WORLD'S COLUMBIAN EXPOSITION 1892.

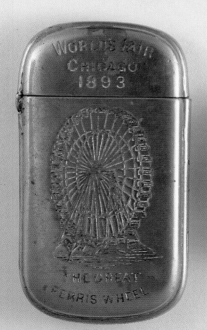

WORLD'S FAIR CHICAGO 1893 THE GREAT FERRIS WHEEL

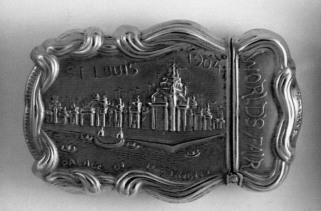

ST. LOUIS 1904 WORLD'S FAIR PALACE OF

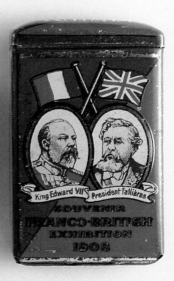

King Edward VII President Fallières SOUVENIR FRANCO-BRITISH EXHIBITION 1908

80

81

78 *Page 82*

Top left. Matchsafe with the Eiffel Tower, c. 1900, Saillard Aîné, Besançon, France, plated metal, 6.4 × 3 × 1.5 cm, 1980–14–442

Top center. Matchsafe with Carrick Castle, c. 1900, possibly William & Andrew Smith, Scotland, wood with transfer printed decoration, 3.2 × 7.3 × 2.3 cm, 1978–146–75

Top right. Matchsafe inscribed "Souvenir of Dreamland, Coney Island, N.Y.," c. 1910, United States, plated metal, printed celluloid, 7.2 × 3.9 × 1 cm, 1980–14–1430

Bottom left. Matchsafe inscribed "Marienbad," late 19th century, Europe, lacquer inlaid with mother-of-pearl and various stones, 4.2 × 6.4 × 1.6 cm, 1982–23–60

Bottom center. Matchsafe inscribed "Dinna Forget," 1907–8, J. Cook & Sons, Birmingham, England, silver, enamel, 4.5 × 3.2 × 1 cm, 1982–23–119

Bottom right. Matchsafe inscribed "Old City Gates, St. Augustine, Fla.," c. 1910, Watson Company, Attleboro, Massachusetts, brass, 4 × 6.3 × 1 cm, 1980–14–1369

79 *Page 83*

Top left. Matchsafe commemorating the Pan-American Exposition, 1901, Whitehead & Hoag Company, Newark, New Jersey, plated metal, printed celluloid, 5.8 × 3.7 × 1 cm, 1980–14–1434

Top center. Matchsafe commemorating the Grand Central Palace Exposition, New York, 1893–94, United States, plated brass, 7.3 × 3.9 × 1 cm, 1978–146–86

model for a matchsafe inscribed "Cairo '93" (fig. 81). Scottish souvenirs came in the form of match containers with sentimental messages like "Dinna Forget" and wooden boxes printed with scenes of famous local castles (see page 82 top center, bottom center). Favorite American tourist destinations from the turn of the century included Yosemite and the other newly designated National Parks, as well as old colonial cities like St. Augustine, Florida, whose historic city gates and Fort Marion are commemorated on a stamped brass match container encircled by an alligator motif (see page 82 bottom right).

An inexpensive matchsafe ornamented with polychrome pictures of Dreamland at Coney Island in Brooklyn celebrates the rise of this phenomenally popular amusement park for New York City dwellers (see page 82 top right). Most Coney Island visitors arrived via the New York subway system, first opened in 1904. A silver matchsafe from around that time, inscribed "Subway N.Y.," is ornamented with an image of a train car tunneling its way into the new City Hall station (fig. 82).

Among the most popular tourist destinations during the age of matchsafes were the spectacular World's Fairs, held in major cities around the globe starting with the first one in London in 1851. Displaying contemporary fine arts, architecture, design, technology, scientific discoveries, and commercial products, these international expositions attracted millions

82

Top right. Matchsafe commemorating the World's Columbian Exposition, 1892, F. M. Whiting, North Attleboro, Massachusetts, silver, 6 × 3.5 × 1.2 cm, 1980–14–1429

Bottom left. Matchsafe with giant Ferris wheel commemorating the World's Fair, Chicago, 1893, United States, plated brass, 7.3 × 4 × 1 cm, 1980–14–1115

Bottom center. Matchsafe with the Palace of Electricity commemorating the World's Fair, St. Louis, 1904, James E. Blake Co., Attleboro, Massachusetts, metal, 4.4 × 6.5 × 1 cm, 1980–14–68

Bottom right. Matchsafe commemorating the Franco-British Exhibition, 1908, for B. Muratti Sons & Company Ltd., London, tin-plated metal, enamel, 6 × 3.5 × 1.1 cm, 1982–23–59

80

Matchsafe inscribed "Souvenir" and "Nice," 1900–10, Italy, inlaid wood, enamel, sandpaper, 6.3 × 3.8 × 1.5 cm, 1982–23–177

81

Matchsafe in the form of a mummy inscribed "Cairo '93," c. 1893, possibly Europe, patinated brass, 6.9 × 3 × 1.3 cm, 1982–23–151

82

Matchsafe inscribed "Subway N.Y.," c. 1904, T. S. Gilbert, North Attleboro, Massachusetts, silver, 6.5 × 3.8 × 1 cm, 1980–14–1426

of visitors. They also served as critical forums for the exchange of ideas, especially in the years before instant photographic reproductions, radio, television, and other forms of mass media.

Visitors to the World's Fairs could choose from a copious range of souvenir guide books, maps, and other mementos ornamented with images of fairground buildings and special attractions. Hundreds of pocket matchsafe designs were commissioned to commemorate the Fairs. The 1892–93 Chicago World's Fair, commemorating the four hundredth anniversary of Columbus' "discovery" of America, inspired a full array of souvenir pocket matchsafes. A silver model with two globes against a background of oak and laurel leaves is inscribed "World's Columbian Exposition 1892" (see page 83 top right). A less expensive nickel-plated brass case is impressed "World's Fair Chicago 1893" and sports an image of the giant Ferris wheel, a novelty introduced at this exhibition (see page 83 bottom left). The St. Louis World's Fair of 1904 was commemorated by a pocket matchsafe ornamented with the exposition's grand Palace of Electricity (see page 83 bottom center).

Big expositions of various kinds were popular in the years around the turn of the century and were held, barring political interruptions, nearly every year. The Grand Central Palace Exposition, held in New York City in 1893–94, is remembered by a pocket matchsafe made of plated brass (see

83

84

page 83 top center). B. Muratti Sons, manufacturer of Ariston Cigarettes, issued a tin match case ornamented with portraits of English King Edward VII and French President Armand Fallières as a souvenir of the Franco-British Exhibition of 1908 (see page 83 bottom right). A matchsafe commemorating the Pan-American Exposition of 1901 in Buffalo, New York, shows a banner on one side, and, on the other, two Loie Fuller–like scarf dancers carefully arranged in the shape of North and South America, hands joined across the isthmus (see page 83 top left).

Other types of public events that manifested themselves in the ornamentation of commemorative matchsafes included all manner of political affairs. The sinking of the U.S. battleship *Maine* in Havana harbor during the Spanish-American War of 1898 inspired the design of a brass matchsafe inscribed "Remember the Maine" (fig. 83). A silver matchsafe titled "Our Heroes," advertised in *The Jewelers' Circular* in 1898, also commemorated the war. It was ornamented with "portraits of live War Heroes" including President McKinley, Admiral Dewey, Captain Sigsbee, General Miles, and the Honorable Fitzhugh Lee.

Famous people of the day were other popular subjects for commemorative matchsafes. Queen Victoria's long reign over Britain and her empire is well documented by vesta cases. The British match manufacturer Bryant and May issued inexpensive tin boxes printed with the Queen's portrait from at least the 1870s. A slightly more elaborate silver-plated matchsafe, round in shape, has a brass bust of Victoria and on an enameled banner the legend "In commemoration 1837–1897," celebrating her diamond jubilee year (fig. 84). The coronations of King Edward VII in 1901 and King George V, both of Britain, in 1910 were both commemorated by matchsafes. A popular model was made of vulcanite, in book form, ornamented

83

Matchsafe inscribed "Remember the Maine," c. 1898, William Schimper & Company, Hoboken, New Jersey, brass, 3.2 × 6.3 × 1.2 cm, 1980–14–1161

84

Matchsafe with bust of Queen Victoria, c. 1897, England, plated brass, enamel, 5 × 5 × 1.5 cm, 1978–146–264

85

Advertisement for the "Columbus Pocket Match-Safe," by G. N. Thurnauer, New York, published in *The Jewelers' Circular and Horological Review*, December 7, 1892. The Art and Architecture Collection, Miriam and Ira D. Wallach Division of Art, Prints, and Photographs, The New York Public Library, Astor, Lenox, and Tilden Foundation

85

with molded busts of the sovereigns. Other models incorporated photographic reproductions.

A number of the British prime ministers, including Disraeli and Gladstone, were memorialized by novelty pocket matchsafes made in the shape of portrait heads. Among American presidents and presidential contenders who were commemorated in this way were Benjamin Harrison, William Jennings Bryan, and Ulysses S. Grant. Match cases in the shape of the heads of famous historical figures were also popular. An advertisement in an issue of *The Jewelers' Circular and Horological Review* from December 1892 illustrates a box in the form of the head of Christopher Columbus, available in oxidized silver and nickel plate for $2.00 per dozen, issued for the world Columbian Exposition of that year (fig. 85).

More private, individual commemoratives also weave their way through matchsafe designs. Personal messages are found on inexpensive plated boxes and fine silver models alike. Family occasions like weddings, holidays, and birthdays were memorialized by inscriptions on match containers. Even on the most profusely modeled cases, some blank space was nearly always left for the engraving of an owner's monogram, family crest, or other personalizing motifs.

Chapter Nine

Japan and the East

Europe's enduring fascination with the exotic treasures and design traditions of the East stretches back thousands of years. During ancient and medieval times, camel caravans coursed the Silk Road across central Asia, carrying back luxurious silks, metalwork, and ceramics. New ocean shipping routes discovered by explorers of the Renaissance era brought exquisite lacquers and porcelains from China and aromatic spices from the East Indies. Throughout the eighteenth century, Western chinoiserie designs, a home-grown mix of Chinese, Indian, and other Eastern motifs, were popular throughout the courts of Europe and in the American colonies.

The reopening of trade between Japan and the West in the 1850s launched a new era of fascination with Eastern design for Europeans and Americans. After more than two hundred years of isolation, Japan began to export shiploads of woodblock prints, lacquers, pottery, textiles, metalwork, furniture, precious boxes called inro, and carved netsuke and other sculptures. Japanese arts and crafts were featured at special exhibitions in London in 1854 and 1862, and were wildly popular attractions at the 1867 Paris World's Fair. An imitative style based on Japanese design, known as Japonaiserie or Japonisme, began to make its mark in European fine and decorative arts.

Enthusiasm for Japanese arts and crafts had a tremendous impact on pocket matchsafe design (pages 90–91). By the last decades of the nineteenth century, thousands of metal match cases made in Japan were exported to the West. And starting in the 1870s, many boxes made by European and American manufacturers were designed to imitate the Japanese style. Some of the characteristics of Japanese design that appealed to Westerners were bold asymmetrical compositions, an emphasis on naturalistically rendered plant and animal forms, and the use of

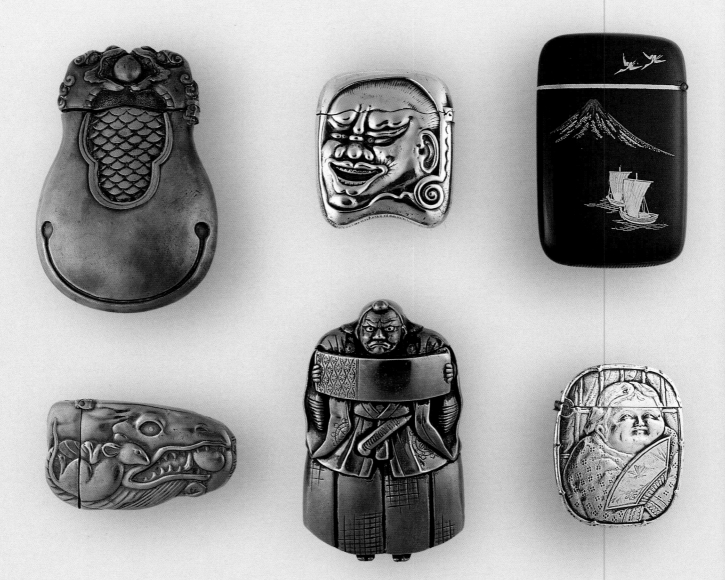

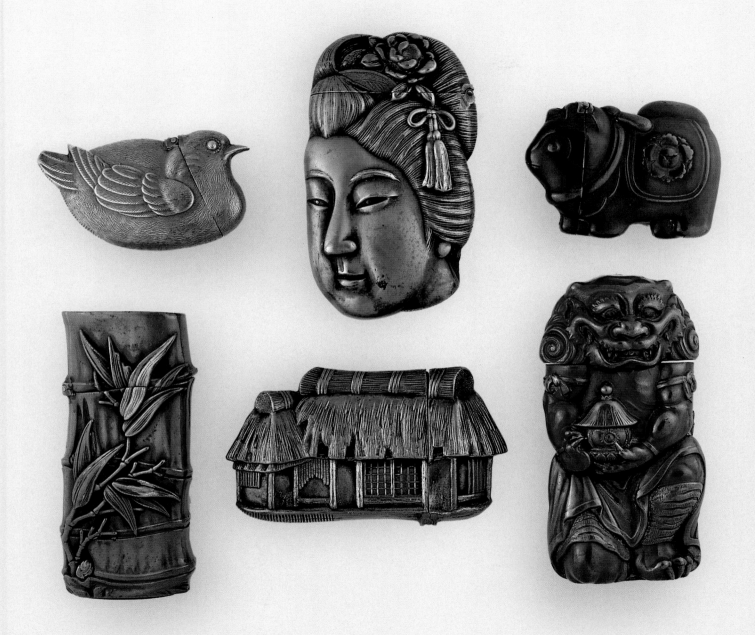

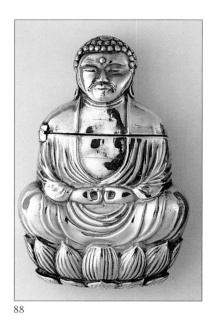

88

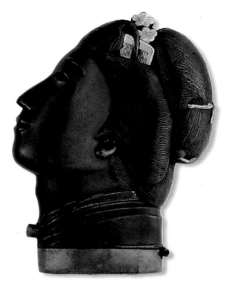

89

Buddhist symbols and other non-Western motifs. Traditional metalworking techniques of skilled Japanese artisans were also deeply admired and often emulated.

Pocket matchsafes made in Japan include many figural pieces. Demons, dragons, gods and mythological beings, landscapes, and other flora and fauna were popular subjects. Numerous match cases were made in the form of *Oni*, a mischievous household demon with short horns and clawed fingers and toes (see page 91 bottom right). A matchsafe shaped like a Bodhisattva seated on a lotus pedestal and one that takes the form of a gong with dragon terminals are typical of match cases modeled after gods and other sacred objects (fig. 88, page 91 top left). Elegant geishas, poignant symbols of traditional Japan, also made their mark (see page 91 top center). Match cases shaped like Japanese *Noh* theater masks were made in a variety of models. Sublime landscapes, especially like the ones depicted on Japanese lacquerwares, were often the inspiration for match case decoration, as seen on a box featuring a sailing vessel in front of a mist-shrouded Mt. Fuji (page 90 top right).

Although many Japanese matchsafes were made from inexpensive metals like brass or copper, they were often exquisitely modeled, with loving attention to detail. The individual hairs of a mouse's fur are delicately picked

Top right. Matchsafe in the form of a cat, late 19th century, Japan, patinated copper, 3 × 4.5 × .9 cm, 1982–23–1333

Bottom left. Matchsafe in the form of a bamboo stalk and foliage, late 19th century, Japan, patinated and gilded copper, 6.7 × 3.1 × 1.3 cm, 1978–146–146

Bottom center. Matchsafe in the form of a Japanese thatched-roof house, late 19th century, Japan, brass, 3.7 × 6.6 × 1.1 cm, 1982–23–218

Bottom right. Matchsafe in the form of the demon *Oni* holding a lantern, late 19th century, Japan, patinated copper, 7.3 × 3.7 × 2.2 cm, 1982–23–1349

88

Matchsafe in the form of a Bodhisattva seated on a lotus blossom, late 19th century, possibly Japan, plated metal, 6.3 × 4.2 × 1.2 cm, 1982–23–210

89

Matchsafe in the form of a geisha's head, late 19th century, Japan, patinated brass, gilding, 6.7 × 4.7 × 1.4 cm, 1978–146–347

90

Matchsafe in the form of a sword hilt with fishing boats and water birds, late 19th century, Japan, shakudo, gold, 5.2 × 2.6 × 2 cm, 1982–23–243

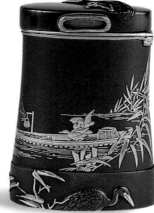

90

out on one case, for example, and on another the feathers of a bird are patterned to suggest perfectly the soft downy surface of a dove (page 91 top left). On a number of different matchsafes modeled after the heads of geishas, their intricately arranged ceremonial hairdos are carefully depicted, wrapping around from front to back, with combs and other ornaments sometimes highlighted in gilding or other contrasting finishes (fig. 89).

Traditional Japanese metalworking techniques, much admired in the West, were also drawn upon for matchsafe production. When the wearing of swords was outlawed in Japan in the 1870s, master metal craftsmen who specialized in creating ornamental *tsuba* and other sword fittings turned their attention to alternate forms of metalwork. Many special alloys and techniques developed by them over the centuries found their way into matchsafe production. *Shakudo*, made from copper and gold, and *shibuichi*, a fusion of copper and silver, were used to create subtle surface hues. Mixed metal compositions, with inlays of gold, copper, or brass, were used for decorative effects. Some of the finest Japanese matchsafes are those resembling the shape of a sword hilt. One made of *shakudo* has sides inlaid with detailed scenes of fishermen and river boats (fig. 90). Around its broad base is a band of crisp relief decoration of water birds and bamboo foliage. A Japanese matchsafe of brass, ornamented with a

chrysanthemum plant and butterflies has highlights inlaid with copper and silver (fig. 91).

Ivory carving was another well established Japanese craft that translated into matchsafe design and production. Inro, small ornamental boxes usually carried on a belt, were often made from ivory, as were netsuke, intricately carved beads or toggles made for the cords of inro. An ivory match case with decoration similar to that given to inro has carved and patinated vignettes of Japanese women in ornamental kimonos arranged among other patterned panels (fig. 92).

An interesting flow of design ideas and materials ran back and forth between Japanese and European matchsafes in the late nineteenth and early twentieth centuries. While many Japanese matchsafes took the form or decoration of purely Japanese motifs, others were straightforward copies of European designs, usually executed in cheaper metals. Quite a few American matchsafe manufacturers went to great lengths to imitate specific Japanese models or to capture the spirit of Japanese design. A silver matchsafe made by the Gorham Manufacturing Company features a grimacing demonlike face, looking much like a Japanese *Oni* or theatrical *Noh* mask (see page 90 top center). Gorham, Whiting, Tiffany & Company, and other American firms produced matchsafes with mixed metal Japonaiserie designs (see fig. 14).

Silver matchsafes made for export in China, India, and other Asian

91

Matchsafe with chrysanthemum flowers, foliage and butterfly, late 19th century, Japan, brass, silver, copper, 6 × 2.7 × 1.1 cm, 1978–146–1014

92

Matchsafe with geisha, late 19th century, Japan, ivory, pigment, 5.5 × 3.1 × 1 cm, 1978–146–496

93

Matchsafe with bamboo leaves and circular reserve, c. 1900, unidentified mark, China, silver, 5.3 × 3.2 × 1 cm, 1978–146–870

94

Matchsafe with seated female figure amid foliage, late 19th century, probably India, silver, 5.6 × 3.6 × 1.5 cm, 1978–146–1208

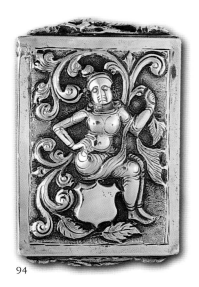

94

lands also found their way west to Europe and the United States. Matchsafes made in China included fine silver filigree boxes, colorful cloisonné enamel cases designed to slide over paper match boxes, and cases of cast and chased silver. A silver case ornamented on one side with bamboo shoots and a circular reserve features Prunus blossoms on its reverse side (fig. 93). Figural scenes, dragons, and stylized lotus cartouches also figure prominently on Chinese cases. Some of the silver boxes made in China are stamped with maker's marks, though most are unmarked. Some other unmarked boxes, similar in form but usually of a lower grade silver, probably originated in India. Many of these are decorated with heavily cast and chased ornamentation of Hindu gods, elephants, tigers, and exotic flora and fauna. A rectangular box with relief figures of dancing goddesses on the top and bottom shows another goddess seated on a shield-shaped reserve amid scrolled foliage on its front, and on its back a standing figure (fig. 94).

Another Eastern wave of influence on European matchsafes arrived in the form of Russian art and design. The fine enameled jewels and other precious objects of Peter Karl Fabergé, Theodore Ruckert, Gustav Klingert, and other Moscow jewelers were well known in Europe by 1890. Pocket matchsafes made in Russia by these and other makers featured cloisonné enamels with colorful geometric designs and painted enamels displaying idealized scenes of Russian peasant life. Some Russian cloisonné enameled matchsafes were imported and sold through Tiffany & Company. Gorham and other firms produced their own enameled matchsafes based on Russian models. Another Russian specialty, niello work, made from silver incised and then filled in with a dark colored metallic substance, also made its mark, both in the importation of Russian examples and in imitations made by European and American matchsafe producers. Russian lacquer boxes, painted with fairy tale vignettes and other figural and landscape motifs, were also imported to Europe in the form of matchsafes (see fig. 36). By the time Sergei Diaghilev's Ballets Russes premiered in Paris in 1909, Russian themes and techniques were well established in the repertoire of Western matchsafe design.

Chapter Ten

The Nature of Matchsafes

A collection of pocket matchsafes can look like a nineteenth-century version of a Renaissance *kunstkammer*, or cabinet of curiosities. These princely protomuseums were proud catalogues of man-made inventions and the marvels of the natural world. Gold, silver, and bejeweled items crafted by the greatest masters were on show, as examples of the genius of man. Also on display here were shells, minerals, and animal specimens never seen before in Europe.

With the expansion of shipping routes and colonial empires, the known world grew and yielded new treasures during the eighteenth century. Many exciting discoveries remained to be made in the nineteenth century. The African continent was still being charted by Europeans when Dr. Livingstone found his way to Victoria Falls on the Zambesi River in 1855. Global exploration continued into the early twentieth century, with Europeans or Americans reaching the North and South Poles in 1909 and 1911.

Among the wonders of the natural world that had appealed to Renaissance collectors and craftsmen were seashells from distant shores, which were often mounted with gold and silver fittings. Nineteenth-century matchsafe makers and patrons carried on the fascination with shells and shell forms, both exotic and native. The New York silversmith George Shiebler included seashell motifs among his inventive matchsafe designs, as in a rectangular box with relief decoration of cowries, augar shells, and periwinkles (see pages 98–99 for this and following matchsafes). A bivalve shell makes a natural box form, closing tight on a natural hinge. A real shell could be fitted with a metal hinge and clasp for a sturdy pocket container, like the one made from a lustrous purple mussel shell, engraved on its reverse "J. Reed, Xmas, 1902."

Perhaps it was proximity to the tidal flats of Narragansett Bay and New

Opposite

Detail of matchsafe in the form of a fish, 1907–8, B. Neresheimer & Söhne, Hanau, Germany, imported by Berthold Müller & Son, Chester, England, silver, 3.8 × 7.5 × 1 cm, 1980–14–1236

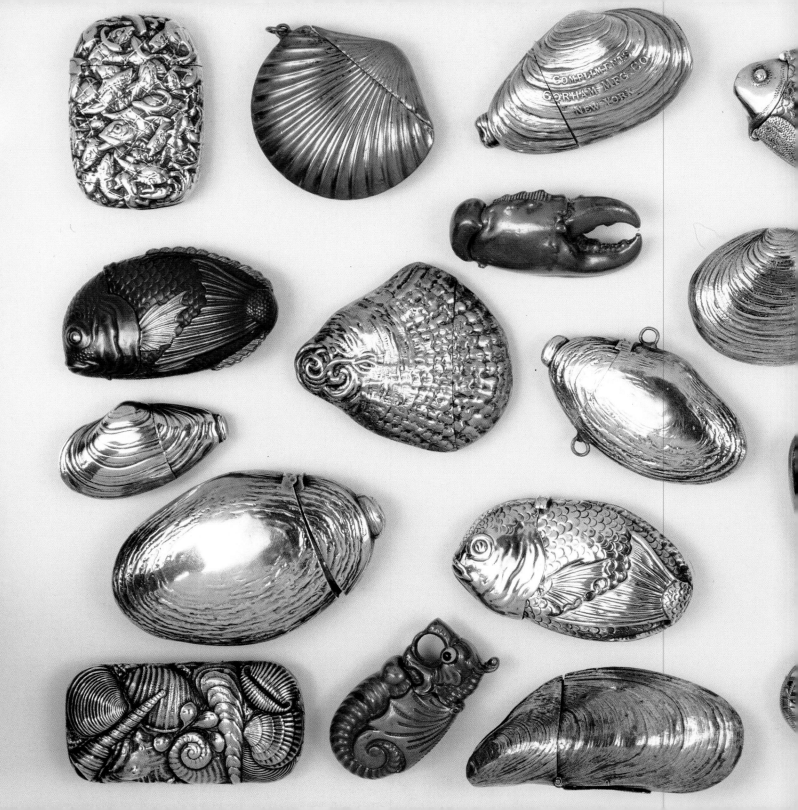

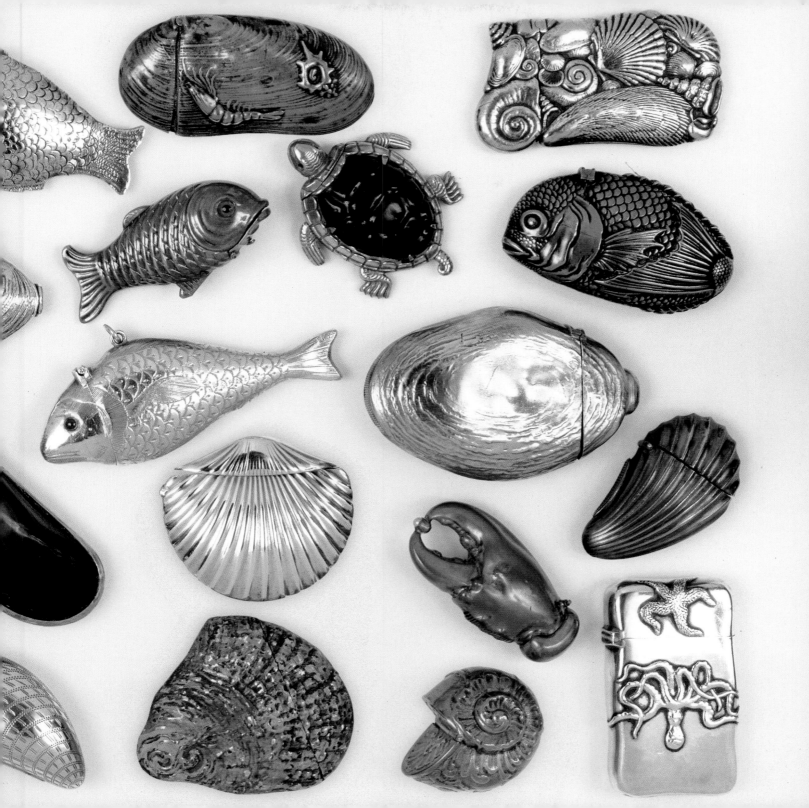

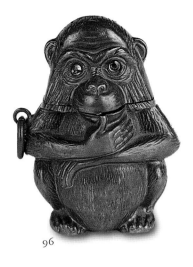

96

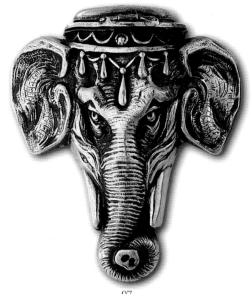

97

England riverbeds that inspired silver companies located in those areas to design so many matchsafes in the shape of clams. Gorham made silver clamshell matchsafes, like the commemorative one inscribed on one side "Compliments of Gorham Mfg. Co., New York," and on its reverse, HMMBA. Another larger model, probably made by Wallace & Sons of Wallingford, Connecticut, is equally life-sized. Matchsafes in the form of oyster shells, scallop shells, razor clams, and other sea shells were produced by many American, European, and Japanese manufacturers in silver, brass, and various white metals.

Fish forms also inspired many matchsafe designs. Since ancient times, fish had been important symbols in both East and West, and they were used frequently as a shape and as decorative devices on all kinds of boxes, charms, and figures. Some fish-shaped matchsafe models were shared between Japanese, European, and British makers. A blunt-headed fish with its tail wrapped around to one side appears both in silver with British hallmarks and in brass or patinated brass without a maker's mark. Another little brass fish with a red glass eye opens to reveal a match receptacle when his ventral fin is depressed. A silver matchbox made by Gorham is ornamented with relief decoration of a fish net overflowing with a bountiful catch.

95 *Pages 98–99*

Matchsafes in the form of shells and other sea life, late 19th–early 20th century, various makers including Gorham Manufacturing Company, George W. Shiebler, and R. Wallace & Sons, United States, England, Europe, Japan, silver, brass, shell, and other materials

96

Matchsafe in the form of a seated monkey, late 19th century, Europe, patinated brass, glass, 5.5 × 4.7 × 3 cm, 1980–14–876

97

Matchsafe in the form of an elephant's head, late 19th century, probably Europe, plated brass, 7 × 6 × 3 cm, 1978–146–133

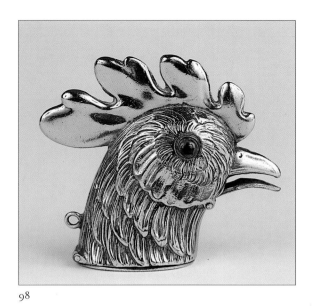

98

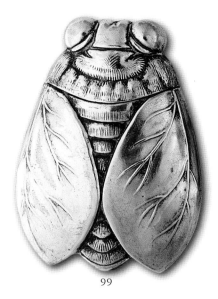

99

98

Matchsafe in the form of a rooster's head, late 19th century, Europe, plated brass, glass, 5.2 × 5.9 × 1.8 cm, 1980–14–1039

99

Matchsafe in the form of a cicada, late 19th century, probably Japan, plated metal, 6.5 × 4.8 × 1.7 cm, 1980–14–1311

Other rare and exotic animals, as well as native European and American species, were also the source for the shapes of many matchsafes. The nature of humankind's relationship to animals was much on the minds of the late nineteenth-century public, especially after the publication of Charles Darwin's groundbreaking book *The Descent of Man* in 1871, introducing the theory of the natural evolution of humans from apes. Matchsafes made in the shape of monkeys and apes appeared, like the model showing one smoking a pipe or another seated in a contemplative pose (fig. 96). Also popular were elephants, tigers, and other exotic animals, many of which were being seen for the first time by American and European audiences at newly established zoos and touring circuses (fig. 97).

Traditional European animal hierarchies are reflected in favorite models for pocket matchsafes. Horses, eagles, hunting dogs, fighting cocks, and other "noble" species often lent their form to match cases (fig. 98). An expanding interest in Japanese design throughout the West brought a heightened appreciation for some of the planet's more humble creatures as worthy subjects. Matchsafes in the form of mice, rabbits, turtles, cicadas, and other insects were made in both Europe and Japan (fig. 99).

Many of the animals used as matchsafe forms may have been chosen based on their ancient symbolic associations. A silver-plated case in the

100

101

shape of an owl's head, with piercing yellow glass eyes, may have appealed because of its affiliation with Athena, Greek goddess of wisdom (fig. 100). The dangerous symbolic powers of snakes and serpents, revered since prehistoric times by peoples around the world, may have attracted fin-de-siècle patrons for their associations to the darker side of symbolist art and literature of the period.

Other animal figure matchsafes incorporated skins, antlers, teeth, and different organic elements in the nature of talismanic charms. A gilded ram's head case features horns carved from a real animal (fig. 101). A matchsafe in the form of a fox was made with a piece of genuine fox tail attached. Another popular model shaped like a dog's head is veneered with animal hide. A matchsafe in Cooper-Hewitt, National Design Museum's collection is fashioned from a hollowed deer hoof and bears on its brass lid the inscription "Killed in Hind's Pool, Aug. 30th, 1888 H.C.W."

Plants and landscape motifs were another aspect of the natural world featured in matchsafe design. Stylized ivy and leafy scrolls were engraved prominently on silver matchsafes made in the English city of Birmingham. Shamrock motifs dominated many Irish match cases made of silver, bog wood, or other materials. Many American souvenir match-safes featured landscape vignettes of noted tourist attractions like Niagara Falls or the National Parks.

It was largely through the fascination with Japanese design that Western matchsafes featured so many themes from nature. Some of the most charming match cases made in Japan for export were in the shape of gourds, root vegetables, or bamboo shoots (see page 91 bottom left). Japanese lacquer and metal boxes often featured serene landscape vistas

100

Matchsafe in the form of an owl's head, late 19th century, Europe, plated brass, glass, 4.3 × 6 × 2 cm, 1980–14–1023

101

Matchsafe in the form of a ram's head, late 19th century, Europe, brass, horn, glass, 3.6 × 5.4 × 2.3 cm, 1980–14–1319

102

Etching design for Match Box No. 5611, c. 1880, Tiffany & Company, New York, pen and ink, wash, on paper. Copyright Tiffany & Co. Archives 2000

102

of Mt. Fuji or misty river scenes. Tiffany & Company and other American manufacturers were inspired to design matchsafes in the Japanese style, emphasizing careful detail of plant forms, asymmetrical compositions, and motifs that wrap naturalistically around the corners of a case. A drawing from the Tiffany archives, dated 1880, presents such a scheme for a matchsafe, with etched decoration of arrowhead plants whose leaves spread fluidly over front and back (fig. 102).

Matchsafe Wit and Charm

In addition to carrying friction matches safely and attractively, some pocket matchsafes did double duty as games, puzzles, conversation pieces, or other forms of personal entertainment (pages 106–7). Comic imagery and gaming functions gave matchsafes one of their most lively secondary uses.

Many figural matchsafes were made in the form of traditional clown figures. A court jester, face framed by a fringed hood and scepter in hand, is the subject of a silver matchsafe made by the Gorham Manufacturing Company (fig. 105). Another American silver case is shaped like a comic grimacing face, tongue extended and eyes crossed in the manner of a Japanese *Noh* mask (fig. 106). Pierrot, a tragi-comic character from the Italian Commedia dell'Arte and pantomime theater, is represented in his balloon suit and pointed hat on an unmarked brass matchsafe (fig. 107).

The figure of Punch, the main character of Punch and Judy puppet shows, was an especially popular motif in matchsafe design. Based on the Commedia dell'Arte character Punchinello, Punch was a rather brutish character who fought mischievously with his wife. He could be recognized by his pointed cap, humped back, hooked nose, projecting chin, and slightly devilish expression. A British brass-plated match case is shaped like a Punch figure shown from his waist up (fig. 108). This model was made in several variations, in both silver and less expensive metals, as were a number of related full-figure models. Often his hands served as a socket for an upright match stick. Other Punch figures were featured on matchsafes that reproduced the cover of the British magazine *Punch*, published from 1841 to 1992, which showed the character Punch seated in a chair alongside his dog Toby.

Contemporary cartoon characters were as popular as the more traditional comic figures in matchsafe design. A British cartoon character known as Ally Sloper is depicted by a figural brass-plated case whose

Opposite

Detail of figure 104, bottom left

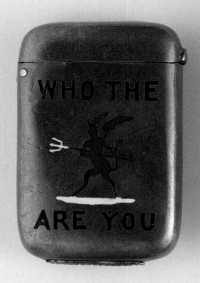

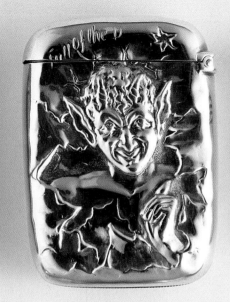

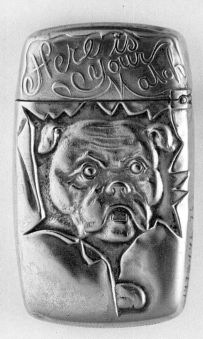

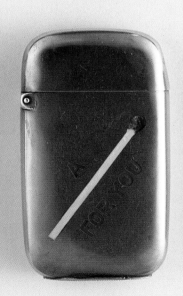

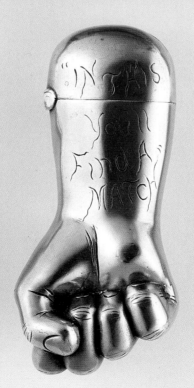

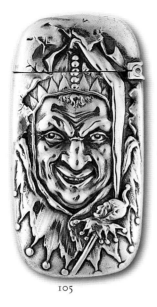

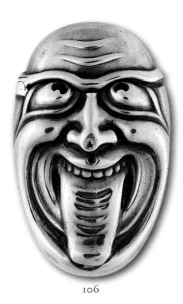

105 106

design was registered in 1888 (fig. 109). Sloper's bulbous nose, rumpled top hat, and rascally character were chronicled by the Dalziel Brothers of London from 1884 to 1923 in their weekly comic paper *Ally Sloper's Half Holiday*, and he is also thought to have been a source of inspiration for the characterizations of actor W. C. Fields (Alsford, *Match Holders*, p. 66).

The Brownies, elfin characters created by American author Palmer Cox, also spirited their way into matchsafe design. Cox's Brownies were published widely, first in *St. Nicholas* magazine and then in the form of a series of books, starting in 1887. Mischievous but charming, the Brownies mounted fishing and horseback riding expeditions, traveled around the globe, and visited the World's Fairs. Their pudgy bodies, slender legs, and pixieish faces are represented on a silver match case made by Gorham that features enameled decoration of two Brownies on a sporting adventure (fig. 110). The Brownies became a phenomenally popular motif for children's toys and nursery furnishings, and were later copyrighted and licensed to advertise commercial products like Eastman Kodak's Brownie camera.

Puzzles and tricks incorporated into matchsafe design included boxes with concealed hinges, false hinges, or hidden release mechanisms. A

Top center. Matchsafe with two donkeys inscribed "Three of a Kind," patented 1893, United States, plated brass, 3.4 × 7.5 × 1 cm, 1980–14–17

Top right. Matchsafe inscribed "In Me a [Match] You'll Always Find," 1886–87, Sampson Mordan & Company, London, silver, enamel, 4.2 × 2.2 × .8 cm, 1978–146–54

Bottom left. Matchsafe inscribed "A [Match] for You at Any Time," 1886–87, Sampson Mordan & Company, London, silver, enamel, 4.9 × 3.4 × 1 cm, 1982–23–54

Bottom center. Matchsafe in the form of a clenched fist inscribed "In This You'll Find a Match," c. 1890, United States, silver, 7.8 × 3.7 × .7 cm, 1978–146–97

Bottom right. Matchsafe inscribed "I Am W.W. King. Who the [Devil] are You," late 19th century, United States or England, brass, 4.6 × 3.7 × .7 cm, 1980–14–1095

105

Matchsafe with the face of a jester, copyrighted 1888, Gorham Manufacturing Company, Providence, Rhode Island, silver, 6.5 × 3.2 × 1.3 cm, 1980–14–360

106

Matchsafe in the form of a face with extended tongue, late 19th century, United States, silver, 6.5 × 3.8 × 1.8 cm, 1980–14–955

107

Matchsafe in the form of a Pierrot figure, late 19th century, Europe, brass, 6 × 4 × 2.1 cm, 1982–23–635

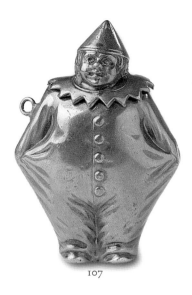

107

type of box with a pivoting two-part lid and concealed catch, made of carved wood or metal, was advertised variously as the "Psycho Box" by a British toy store and the "Magic Fusee Box" by an American novelty company (Alsford, *Match Holders*, p. 87). The opening mechanisms of some matchsafes provided comic surprises, like the model with a tiny figure thumbing his nose that pops out when the lid is released.

Among matchsafes that featured gaming and gambling devices were boxes with compartments for sets of dice. The "Chuck Luck Pocket Match Safe and Dice Box," advertised in an 1895 Montgomery Ward & Company mail-order catalogue, featured "5 dice in sliding cover on one end, which forms a neat Dice Box, when removed." One of these cases now in Cooper-Hewitt, National Design Museum's collection is made of nickel-plated brass and retains its original cellophane-wrapped miniature dice, tucked away under the sliding cover of one end (see page 107 top center). Other matchsafes incorporated counting devices into their decorative schemes. Spinning dials, numbered one through ten or twelve, were frequently set against motifs of playing cards, like on cases made by Gorham, Wallace & Sons, and others. Many matchsafes were designed in the shape

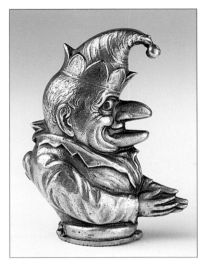

108

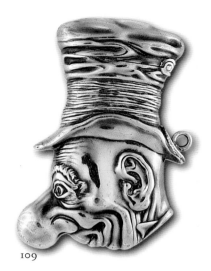

109

of domino game pieces, usually made of celluloid with brass fittings (fig. 111).

Games of a more cerebral nature are represented in the form of pocket matchsafes ornamented with rebuses and other picture or word puzzles. These were very popular, and range from expensive boxes made of silver with fine enameled decoration to inexpensive brass cases with crude incised inscriptions. A clever rebus is featured on a silver matchsafe made in Birmingham in 1895–96, enameled with two cuts of beef and the legend "Tis [rare] That We May Often [meat]" (see page 106 top right). Another silver British case has enameled decoration with the rebus "Just one [pipe] more" (see page 107 top left).

Devils and donkeys, or asses, played starring roles in humorous matchsafe rebuses. The "Chuck Luck" box has two long-eared equines on its front side and the inscription "Three of a Kind" (see page 107 top center). A brass case picturing two donkeys is inscribed "When shall we 3 [asses] meet again?" (see page 106 bottom right). A similar brass box carries the image of a horned devil with his trident and the inscription "I am W. W. King. Who the [devil] are you" (see page 107 bottom right). Gorham produced a match case with chased decoration of a devil's face surrounded by an engraved legend "Full of the D" (see fig. 106 top center).

Not surprisingly, the most popular rebuses and picture or word puzzles were those based on the word "match." An American case featuring

110

111

a menacing looking bulldog is inscribed "Here is your match" (see fig. 106 bottom left). Many less threatening mottos, and ones that speak to the more companionable aspects of smoking culture, are also found on matchsafes. On a silver Sampson Mordan case with enameled decoration is found an inscription that sums up the very mission of these useful and delightful boxes: "In me a [match] you'll always find" (see fig. 107 top right).

Further Reading

Other Resources

Alsford, Denis B. *Match Holders: 100 Years of Ingenuity*. Atglen, Penn.:
 Schiffer Publishing, 1994.

Culme, John. *The Dictionary of Gold & Silversmiths, Jewellers & Allied
 Traders, 1838–1914, From the London Assay Office Registers, vols. I
 and II*. Suffolk, Eng.: Antique Collectors' Club, 1987.

Fresco-Corbu, Roger. *Vesta Boxes*. Cambridge, Eng.: Lutterworth
 Press, 1983.

International Hallmarks on Silver Collected by Tardy. Paris: Tardy, 1985.

The Jewelers' Circular and Horological Review. Also published as *The
 Jewelers' Circular* and *The Jewelers' Circular-Weekly*.

Patterson, Jerry E. *Matchsafes in the Collection of the Cooper-Hewitt
 Museum*. Washington, D.C.: Smithsonian Institution, 1981.

Paulson, Paul L. *Guide to Russian Silver Hallmarks*. Paul L. Paulson,
 1976.

Pickford, Ian, ed. *Jackson's Hallmarks: English, Scottish, Irish Silver and
 Gold Marks from 1300 to the Present Day*. Suffolk, Eng.: Antique
 Collectors' Club, 1991.

Rainwater, Dorothy T., and Judy Redfield. *Encyclopedia of American
 Silver Manufacturers, 4th ed*. Atglen, Penn.: Schiffer Publishing,
 1998.

Sanders, W. Eugene, and Christine C. Sanders. *Pocket Matchsafes:
 Reflections of Life and Art, 1840–1920*. Atglen, Penn.: Schiffer
 Publishing, 1997.

Sullivan, Audrey G. *A History of Matchsafes in the United States*. Ft.
 Lauderdale, Fl.: Riverside Press, 1978.

U.S. Patent Office Official Gazette.

International Match Safe Association
P.O. Box 791, Malaga, NJ 08328–0791, e-mail: IMSAoc@aol.com

Christie's South Kensington, London.
Annual Vesta Cases auctions with illustrated catalogues
(September 15, 1998; October 5, 1999; September 22, 2000).